IRISH
IOWA

TIMOTHY WALCH

THE
History
PRESS

Published by The History Press
Charleston, SC
www.historypress.com

Copyright © 2019 by Timothy Walch
All rights reserved

First published 2019

Manufactured in the United States

ISBN 9781467139700

Library of Congress Control Number: 2018963523

CONTENTS

PREFACE

*F*ailte—that is how the Irish say "welcome" in their native language. Although it is not a common expression among the Irish of Iowa, it does capture the essence and the purpose of this book. At its core, *Irish Iowa* is an introduction to a people facing famine and dire poverty in their native land who later found freedom and prosperity in the American heartland.

Although only one name appears on the title page, this book would not have been possible without the assistance of a small village of archivists, librarians, historians and friends who provided source material, photographs, advice and wisdom that were vital in shaping the content that follows. To each of them, I am deeply grateful.

In particular, I want to acknowledge the contributions of my colleagues at the Iowa City Center of the State Historical Society of Iowa. Mary Bennett, Marvin Bergman and Charles Scott were generous with their time and knowledge and in suggesting photographs that add visual dimension to the text. As with so many research projects on the history of the Hawkeye State, the best place to start is at SHSI in Iowa City.

I am also grateful for the assistance over many years from my friend and fellow archivist Michael Gibson, the director of the Center for Dubuque History at Loras College. For more than forty years, Michael has been the guardian of historical materials in northeast Iowa, and I have benefited immensely from his hard work.

Many other librarians, archivists and librarians provided assistance. I was so fortunate to receive the generosity of Robert Klein, the Librarian

Emeritus of Loras College, with guidance on Bishop Loras's contacts with the Catholic press. So also, I wish to acknowledge the many contributions of the late Sister Madeleine M. Schmidt, CHM, and her successor, Tyla Cole, as archivists of the Diocese of Davenport.

Other archivists were equally generous. Dan Burns at the Archives of the Archdiocese of Dubuque answered questions and provided several excellent photographs. I also was assisted by his predecessor, Father Loras C. Otting. Jennifer Head at the Archives of the Sisters of Charity, BVM; Adam Story of the Archives of the Diocese of Des Moines; and Onnica Marquez of St. Ambrose University were prompt in their responses to my appeals for information and photographs.

Mention also must be made of the assistance I received from local history librarians. Amy Groskopf and Katie Reinhardt at the Davenport Public Library located photographs that I would have otherwise missed, and Thomas Monson at the Sioux City Public Museum generously provided both photographs and reference materials that proved invaluable.

Although she is not a historian, Barb Arland-Fye is an outstanding editor of the *Catholic Messenger* of the Diocese of Davenport. She has been very supportive of the project and provided an important history of the paper, plus the drawing of the Sharon family that appears in the book.

I also want to acknowledge the work on this topic already completed by fellow historians. As is evident in the notes to this book, I was fortunate to benefit from previous work done by the late Homer Calkin, a native Iowan and prolific public historian. His scholarship and clear prose inform many of the chapters that follow. I am also grateful for advice and scholarship from Ryan Dye, professor of history at St. Ambrose University.

In addition to these scholars and curators, I was blessed to have the contributions of numerous "Hibernians" who contributed stories and photographs that add luster to each chapter. Of particular note, I want to mention Dan and Beth Daly of Iowa City. Dan is the embodiment of St. Patrick and, in fact, annually portrays the patron saint of Ireland in the St. Patrick's Day Parade in Cedar Rapids.

I also want to acknowledge John P. O'Brien of Melrose, Iowa. Although we have never met, John was very generous in locating photographs and other information on this very special community. John has been important in preserving the memories of "Little Ireland," as it is known.

Also worthy of special gratitude and acknowledgement are the many individuals who plan and direct the special programs that bring Irish culture and celebration to our state. In particular, I want to salute the Ancient Order

of Hibernians in Dubuque and the Cedar Valley Irish Cultural Association in Waterloo for their work in planning the annual events in their communities.

Notable contributors in Dubuque are Robert McCullough and Robert Felderman, who are among the leaders of the annual Irish Hooley held in the Key City each August. In particular, I want to salute General Felderman, who is a gifted and generous photographer, for allowing me to use his work in this book.

And I was blessed to have the contributions of Rory Dolan and Salina Galvin, who are among the many individuals who ensure the success of the annual Irish Fest that is held in Waterloo each August. Galvin also contributed excellent images that capture the excitement of the event.

Critical to the success of this book have been the contributions of Kenneth Donnelly of Iowa City and West Liberty. Ken taught American history for decades and has always had a special affection for his people, the Irish of Iowa. More important, Ken has been diligent in preserving the documentary record of the Kelly, Gatens and Donnelly families in eastern Iowa. Pictures and stories of these families are woven into the chapters that follow thanks to Ken's diligence and generosity.

This book would not have been possible were it not for the assistance of my wife of more than forty years, Victoria Irons Walch. In addition to providing emotional support and sage advice, she guided the manuscript and the images through the editorial process. As with all my books, her technological skills were essential to my progress.

Finally, it bears emphasis that this book rests on the scholarship of historians whose work is acknowledged in the notes. As such, it should be said, without false modesty, that this book is a synthesis of that previous work. It is my hope, however, that this new presentation will inform and educate all those who take pride in both their Irish and their Iowa roots. *Slainte*, as the Irish would say—good health to you, and happy reading!

Timothy Walch
St. Patrick's Day 2018
Iowa City, Iowa

INTRODUCTION

I owa has always been the middle land, a common ground for many different cultures. There are African, Indian, Hispanic and Asian accents within our state, and each year, they celebrate the rich diversity that people of color have contributed to the meaning of the term "Hawkeye."

Most Iowans trace their cultural roots to Europe—to England and Germany, Scandinavia and the lowland countries, Slovakia and the Czech Republic. And, of course to Ireland, the emerald island with the tragic past.

The Irish came to Iowa for many reasons. Some were attracted by lush farmland west of the Mississippi. Farming in Ireland had become a hardscrabble existence by 1830—too many people and too little land; the only hope for the future was to emigrate.

Iowa offered these Irish farmers the opportunity to own more land than they could imagine, land more fertile than any they had known in their native country. For these farmers, therefore, Iowa was something of a promised land. The long journey by packet ship would be hellish, but the prize would be worth it.

Most Irish families knew nothing of Iowa before they boarded the ships for the United States. They were desperately poor, living on the edge of hunger as farmers on rented land. Indeed, these people had no set plan in fleeing Ireland for America. They were escaping a famine so severe that more than one million of their countrymen would die before it ended.

These poor Irish families were grateful for life itself, and they felt blessed to end up in a nation and later a state that offered hope. But with few skills

and no money, most of the men started as laborers who built Iowa's towns and railroads.

The Irish did not arrive in Dubuque or Davenport or Burlington by sheer chance, of course. In truth, they came because they were invited. Broadsides in the ports of Britain and the United States invited them to move west. Letters and stories appeared in Irish Catholic papers such as the *Freeman's Journal* in New York and the widely read *Boston Pilot*. Everything they read convinced the Irish that they were welcome in Iowa.

And the Irish did become the second-largest immigrant group to come to the state. More important, their knowledge of the English language and the American political system gave the Irish an influence well beyond their numbers.

This book tells the story of the arduous odyssey of people seeking prosperity and identity in a new land. It is both a story of sadness and survival and a story of pride and prosperity. Most important, *Irish Iowa* provides a unique perspective on a people who passed by the big ethnic enclaves in Boston, New York, Philadelphia and Chicago.

The first chapter is titled simply "Pioneers" and tells the story of the earliest Irish immigrants to Iowa. These individuals were the true adventurers who

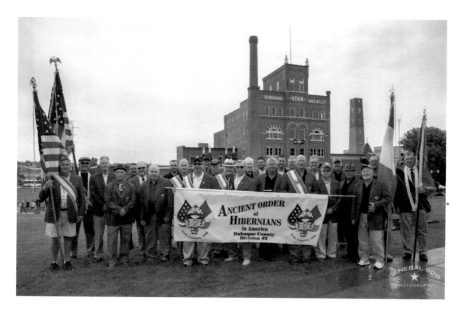

Members of the Ancient Order of Hibernians assembled recently at the annual Irish Hooley in Dubuque. *Courtesy of Robert Felderman/General Bob Photography.*

were willing to come to Iowa a decade or more before statehood. The first bishop, Mathias Loras, found these Irish to be both a blessing and a curse, and this chapter tells of the conflicts between the bishop and his Irish communicants.

The second chapter is titled "Farewell to Famine" and focuses on the journey from Ireland to Iowa that was precipitated by famine in the years after 1846. Particular attention is paid to the pilgrims who established the monastery at New Melleray in Delaware County and the town of Wexford in Allamakee County.

Chapter three is titled "Faith of Our Fathers" and examines the vital role played by bishops and pastors in the nurture and development of the Irish community in Iowa. The two bishops who succeeded Loras—Clement Smyth and John Hennessy—for example, were born in Ireland, and they were the secular as well as the spiritual leaders of the Iowa Irish.

The next chapter, "Sisters of Erin," tells the story of the Irish women who immigrated to Iowa. In addition to tens of thousands of wives and mothers, there also was a mighty band of devoted women religious. These women established orders that provided hundreds of Irish-born sister teachers to staff the parochial schools across the state. It must be said time and again that Irish women—both lay and religious—changed Iowa's landscape, and those changes are highlighted in this chapter.

Chapter five focuses on the story of the Iowa Irish in the emerging urban communities in the Hawkeye State. Often arriving in Iowa with limited funds and only basic skills, the Irish sought comfort in the Irish neighborhoods of Dubuque and Davenport and later in Des Moines, Sioux City and other Iowa cities. This was a pattern of settlement similar to what was happening in eastern cities such as Boston and New York.

The next chapter focuses on those Irish who pushed beyond the cities to Iowa's rolling prairies. Although isolated from their fellow countrymen, these industrious Irish farmers never forgot the land of their birth and established small rural communities that recalled the landmarks of their heritage.

Most of the Iowa Irish, however, were not fortunate enough to farm the rich land of the state. "Their Daily Bread" tells the story of the Irish working class—the men who built the railroads and worked in the factories and shops. It tells the story of the women who washed clothes and minded children. The chapter also captures the stories of some of the Irish who climbed up from poverty to "make it" in the state.

"I Am of Ireland" focuses on Irish nationalism in the Hawkeye State. Throughout the nineteenth century, the Irish in Iowa celebrated their

ethnicity and championed the cause of Irish independence. The movement reached a high point in the visit to Iowa of Charles Stewart Parnell, the leader of the New Ireland campaign. This chapter culminates with a discussion of the reaction of the Iowa Irish to the Easter Rising of 1916 and the civil war that followed.

"No Irish Need Apply" tells the story of anti-Irish hostility. Beginning in the 1850s, many Iowans supported the Know-Nothing Party to resist any further immigrant influence in the Hawkeye State. The Irish were among the most visible targets of Know-Nothing hostility. The chapter also recounts one of the ugliest chapters in Iowa history: the founding of the American Protective Association in Clinton in 1892. The hostility of the APA was felt deeply by the Irish in Iowa.

"Hills and Dales" tells the story of the progress made by the Irish community in the first two decades of the twentieth century, followed in the 1920s by hostility from an emerging Ku Klux Klan. The conflict came to a head with a dilemma in 1928: Should the Irish vote for Iowa's native son, Herbert Hoover, for president? Or should they vote for their fellow Irishman and co-religionist, Alfred E. Smith?

Chapter eleven focuses on a decade of economic depression beginning in 1930, followed by five years of world war. The sheer struggle to survive in the

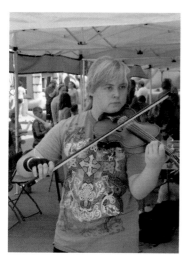

The future of Irish culture and heritage in Iowa is manifest in young people who perform each year at Irish Fest in Waterloo. *Courtesy of Salina Galvin.*

'30s is told through the memories of Leo R. Ward, priest, author and, most importantly, son of Melrose, Iowa. His book *Holding Up the Hills* provides a portrait of how the rural Irish of Iowa coped with drought and crop loss. The chapter then shifts to Waterloo to focus on the Sullivans—an ordinary family who suffered extraordinary loss during World War II. The patriotism of the Iowa Irish is epitomized in the sacrifice made by the five brothers who died together at sea.

The final chapter is titled "Forever Irish" and concentrates on the determination of the Iowa Irish to carry on the traditions of their ancestors. Iowans of Irish ancestry live in every one of the state's ninety-nine counties, and that ancestry is celebrated annually in dozens of St. Patrick's Day parades across the state. This chapter traces

the ways and means that Iowans renew and refresh their determination to stay forever Irish.

These chapters fit together like a quilt to reflect the diversity of the Irish experience in the Hawkeye State. It is important to note, however, that this book only touches the surface of what it means to be Irish in Iowa over the past century and a half. It remains for others to step forward and provide greater depth and nuance to the chapters that follow.

CHAPTER 1

PIONEERS

I t was not the land that attracted the first Irishmen to Iowa. To be sure, they could not help but be impressed by the sight of endless, waving grass as far as the eye could see. There was nothing like it in Ireland, where they had farmed small plots of land broken up by hedgerows.

What lured these pioneers was a dull but valuable metal called lead. News of lead deposits west of the Mississippi River attracted an adventurous breed to the mining town of Galena in Illinois. These men coveted the rich deposits on the riverbanks, but they crossed the Mississippi at their own peril. In 1830, the land that is now Iowa was controlled by the infamous Chief Black Hawk.

But the lure of that dull metal was impossible to resist, and in the spring of 1830, a group of miners took possession of the lead deposits in what would become the frontier town of Dubuque. Many were Irish—men named Dougherty, McDowell, McCabe, Murphy, O'Regan and Curran. They did not wear their nationality on their sleeves; they were miners. And yet they never forgot their heritage.

In crossing the Mississippi in 1830, these men were breaking the law. The United States government had deeded the land to Black Hawk and promised to keep the white man—Irish or not—east of the river. And as soon as the authorities learned that miners had crossed to the West, federal troops drove them back across to Galena. For the government, peace with Black Hawk was far more important than a few more lead mines.

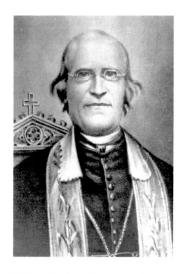

Bishop Mathias Loras was tireless in his efforts to attract Irish immigrants to his new diocese. *Courtesy of the Center for Dubuque History.*

The lead miners were a stubborn lot, however. Over the next three years, they fought with soldiers and Indians alike. Black Hawk's War, as the conflict came to be known, was a sad affair that ended with the chief ceding much of northeast Iowa to the white man. By the middle of 1833, four to five hundred settlers had crossed the river to begin the settlement of Iowa; many of these pioneers were Irish.

Their fortunes were mixed. Without question, these Irishmen were adventurers. Who else would settle west of the Mississippi in the 1830s? Aside from the miners, they were a motley crew: a few were entrepreneurs who became city leaders, but many were laborers and shopkeepers. They all contributed to the hustle and bustle of early Dubuque.

It was, of course, the mining operations that were the focus of early attention. The work was hard, and the Irish looked for every opportunity to escape the burdens of life in the mines. Not surprisingly, the saloons of Dubuque became the Irishmen's social club, and many miners drank and gambled away their pay.

One antidote to frontier hardship was religion. As Catholics, the Irish of Dubuque sought out the services of a priest. As if by divine intervention, Father Charles Van Quickenborne arrived in Dubuque in July 1833, little more than a month after the main body of settlers. Shortly after his arrival, Quickenborne baptized the son of Patrick and Mary Monaghan, making Henry Monaghan the first Catholic to be baptized in the territory.[1]

Quickenborne's stay was productive. He celebrated Mass each day at the home of a "Mrs. Brophy" and set up a committee of local Catholics to raise funds to build a church. Among the members of the committee were James Fanning, James McCabe, Patrick O'Mara and Thomas Fitzpatrick, all Irish immigrants.

Quickenborne left at the end of the summer to be replaced in 1834 by an Irish-born priest named Charles J. Fitzmaurice. Upon his arrival, Fitzmaurice learned that the church committee had already purchased land and raised over $1,000 to build a church.

That bit of good news was the one bright spot in a hard life for the missionary. Among his first pastoral responsibilities was to minister to an Irishman named Patrick O'Connor who had been convicted of murder. His condemnation of those involved in the affair would isolate Fitzmaurice from his flock.[2]

There was no dispute over the facts of the case. In the fall of 1833, O'Connor had shared a cabin with a fellow miner named "O'Keaf." Returning with provisions one rainy day, O'Keaf asked O'Connor to open the cabin door. O'Connor refused, so O'Keaf pushed the door open. O'Connor's response was to shoot and kill his cabin mate.

Justice on the frontier was swift. The miners held a trial and condemned O'Connor to death on June 20, 1834. Fitzmaurice knew that the trial was not legal, and he was determined to stop the hanging.

Marshaling all of his religious authority, the priest condemned those involved and called the decision to hang O'Connor illegal and unjust. Although new to the community, Fitzmaurice carried some weight with the Irish. His appeals would be for naught, however, and O'Connor was marched to the gallows.[3]

True to his religious convictions, Fitzmaurice stayed with the condemned man until the very end. He heard O'Connor's confession and ministered the last rites of the Church. In fact, the two men—priest and penitent—rode together to the execution in the condemned man's coffin!

Fitzmaurice's involvement in the case also had an unintended consequence. A rumor spread within the community that a band of armed Irishman was on its way from Wisconsin intent on freeing O'Connor. Although the story was false, it galvanized the non-Irish miners who shouldered their weapons and proceeded to carry out the sentence.

The tangled lives and tragic deaths of O'Connor and O'Keaf were an auspicious beginning for the Irish in Iowa. For many, the notoriety of the incident confirmed the worst fears of Irish and non-Irish alike: that the Irish were too temperamental to contribute to the establishment of a new state.

Father Samuel Mazzuchelli was an Italian missionary priest who worked among many Irish communities in Iowa in the years before the Civil War. *Courtesy of the Center for Dubuque History.*

17

Even Fitzmaurice could not escape the tragedy. Distrusted by many for his controversial efforts to save O'Connor, the priest had little impact on the moral life of this frontier community. He died in a cholera epidemic early in the spring of 1835.

Other Irish pioneers were spared the tragedy that gripped O'Connor, O'Keaf and Fitzmaurice. John Foley and Patrick Quigley, for example, were elected to serve Dubuque in the Wisconsin Territorial Legislature. And many of the two hundred Irishmen living in Dubuque in 1835 became wealthy from lead mining.

Ironically, it was an Italian-born missionary priest who brought peace to the troubled souls of the Irish in Iowa. Father Samuel Mazzuchelli arrived in Dubuque in July 1835, and with the aid of Patrick Quigley, the priest set up a chapel in a spare room of the Quigley home. He also convinced the Irish to fulfill their pledges to build a permanent church. Perhaps a better indication of his popularity was the fact that even non-Catholics contributed to the building campaign.[4]

The cornerstone was laid in August, but progress slowed, and the church was not ready for worship services until late in the fall of 1836. Indeed, the building would not be finished until 1839. By then, Mazzuchelli had moved on to other communities in the state in need of a priest.

Peace, however, was no guarantee that the Irish population would move west to the Iowa frontier. The work would be hard, and the need was limitless. Men had to clear the forests, break the prairies, lay out the roads and build the bridges. And if Iowa was to prosper, immigrants were needed to bring the railroad to the state. Frontier Iowa was a land of promise, and the pioneers who had crossed the Mississippi had to convince their fellow countrymen in the eastern cities to venture west.

It is hard to use the term "promotion" in the context of the 1840s, but that is what the first Irish Iowans did in sending letters back east to local newspapers. They boasted and promised the Irish immigrants of New York, Boston and Philadelphia that they should move west to find prosperity.

It was destiny and perhaps God's will that the Irish should move west. "Of all the foreigners," wrote one correspondent in the *Burlington Hawkeye* in 1844, "none amalgamate themselves so quickly with our people as the natives of THE EMERALD ISLE. In some of the visions which have passed through my imagination, I have supposed that Ireland was originally part and parcel of this continent and that by some extraordinary convulsion of nature, it was torn from America and, drifting across the Ocean, it was placed in the unfortunate vicinity of Great Britain."[5]

Charles J. Corkery worked closely with Bishop Loras to attract his fellow countrymen to Iowa—"the Eldorado of the West."
Courtesy of the Center for Dubuque History.

The readers of the *Hawkeye*, the leading paper of the Iowa Territory, must have been impressed. That the Irish were needed in Iowa was without question, but more had to be done to convince them to leave eastern cities and venture west. To validate this gamble, the Irish needed to hear directly from fellow Catholics who had already established themselves in the state.

Throughout the 1840s, a committee of Iowa Irishmen wrote to Catholic newspapers in New York and Philadelphia with letters about the opportunities available across the big river. Led by Charles Corkery, the committee validated the reality of prosperity. "My sole desire," wrote Corkery to the *Philadelphia Catholic Herald* in July 1841, "is to direct the attention of Catholics (Irish Catholics more particularly) to the country little known and less appreciated in the East."[6]

And Corkery wanted to assure readers that the appeal of the West was not unique to him. He was no huckster. He spoke for the Irish who were already living in Dubuque and Davenport and the eastern counties of the Iowa territory. "I have had ample opportunities of bearing witness," intoned Corkery, "to the testimony of many able and respectable writers (travelers and others) who unite in giving Iowa the happy cognomen of 'the garden of America.' The Eldorado of the West."

Corkery may have had a touch of hyperbole in his prose, but he knew how to entice his fellow countrymen who hungered to return to the land—to plant crops as they had done in the old country. "Irishmen unite in saying," he added, "that our wheat and oats are nothing inferior to those of Ireland and I have never seen better potatoes in Ireland than those raised in [Iowa]."

Corkery and his committee were joined in their campaign by Bishop Mathias Loras of Dubuque. Although not of Irish heritage, Loras understood implicitly that his new diocese would benefit greatly by devoted communicants who already spoke the English language. Together, Corkery and Loras wrote numerous letters to the *Boston Pilot* and other Catholic papers throughout the 1840s and 1850s. "Let good emigrants come in haste to the west of Iowa," wrote Loras in 1854. It was both a command and an invitation.[7]

But some of the Iowa Irish were concerned about making too much of the opportunities in their new state. Michael O. Sullivan of Dubuque, for

example, cautioned emigrants to be prepared for hard work. "They must not be too sanguine," he warned. "They must consider the genius of a rising community. They must not be shocked at the idea of living in a log cabin or wearing rough clothing and, at first, of sacrificing many things they enjoyed in the old home. If they come fortified with industrious and steady notions they will certainly prosper."[8]

Indeed, they would prosper. During the 1840s, numerous Irishmen crossed the river and purchased land in Dubuque, Jackson, Linn, Johnson and Jones Counties at a cost of four to eight dollars per acre. Impoverished emigrants unable to purchase their own land could work for hire at a rate of thirteen dollars a month plus room and board. It was a hard life but well worth the effort. As Sullivan noted in a second letter to the *Pilot*, many of the first emigrants to the Iowa territory who had started with a few acres now owned 160 to 640 acres and had no debt.

But a pioneer's life was not for everyone. James McKee, an early Irish resident of Washington County wrote to a friend in Pennsylvania about his new life and land. "I shall not attempt to describe the appearance of the country," McKee wrote in July 1848. "But there is one thing I know: that it does not suit any old country man to get into the timber and make a farm. It is enough to discourage them. I know that it has done so with a great many."[9]

And yet McKee did not want to discourage his friend to come west. "If you want to get a farm," he wrote, "this is the place for you." Just as important, McKee notes the sense of democracy and liberty that came with being your own man in a new land. "These people are more on an equality with one another than they are [in Pennsylvania]. Should you come out here, I hope it will not be long."

McKee had one final piece of advice for his friend: don't be too much of an Irishman. "If I am able to render any service, [it will be] that people will be calling you a 'green' Irishman. Do not be rash in speaking your sentiments to any 'country-born' respecting the Emerald Isle—or anything pertaining to it."

Sullivan, McKee and the first Irish to settle in Iowa provided good advice to the second wave of settlers who arrived in the 1840s. The value of their advice was evident in the settlements that emerged quickly in the 1840s in the counties that surrounded Dubuque and Davenport and then spread across the state to Cedar Rapids, Iowa City and Des Moines in the late 1840s and 1850s.

The farming community of Garryowen in Jackson County is a good example of the transition from frontier settlement to prosperous town. It

Mother Mary Frances Clarke moved the Sisters of Charity of the Blessed Virgin Mary from Ireland to Philadelphia to Dubuque in 1843. *Courtesy of the Sisters of Charity, BVM.*

began with a cluster of Irish families who had settled twenty miles from Dubuque. Together, they established a church and then a school, and these vital institutions, plus the availability of good land, attracted numerous families from Cork and Limerick in Ireland. In 1840, there were 100 Irish communicants in the parish; the next year, the number had jumped to 260, and by 1843, there were 600 Irishmen living in and around Garryowen. By 1850, there was no unoccupied farmland in the township that surrounded the town.[10]

Garryowen was not exceptional; in fact, it was typical of the pattern of Irish settlement in the state. And yet the Irish seemed to blend in so well as to be invisible among the other Europeans who had settled in the Hawkeye State. The editors of the *Boston Pilot* correctly noted that "[Iowa] is full of colonies of [Germans], Norwegians, Portuguese, and Hollanders while the Irish though they are *everywhere* in units are nowhere together."[11]

Although they did not get much recognition, the Irish were pioneers in the settlement of just about every one of Iowa's counties. They settled in the cities in sizable numbers and took up a wide range of occupations. It is also important to recognize that the Irish had an important part in the agricultural heritage of the state. Over the next generation, the opportunities offered by cheap, abundant and fertile land would continue to draw the Irish to Iowa.

CHAPTER 2

FAREWELL TO FAMINE

The advertisement appeared on page three of the *Waterford Daily Mail* on October 18, 1851. It was modest in size but profound in importance. "Immigration from Ross to New Orleans" was the headline, and it was sure to catch the eye of restless Irishmen who were still suffering the vestiges of a famine known in the native Irish language as *An Gorta Mor*—the Great Hunger.[12]

The advertisement promised a "splendid" journey on a packet ship with a name that portended the future of a people in a new land. The *Iowa*, as it was christened, was a 1,650-ton sailing ship with nine feet of headroom between decks. It promised its passengers relative comfort at affordable prices, and readers were encouraged to contact William Graves in New Ross or George White in Waterford for more information on booking passage.

The destination would have been a surprise to some discerning Irishmen contemplating emigration. Why New Orleans as a port of entry? Why not more common and popular ports such as Boston, New York and Philadelphia? The advertisement made the matter quite clear.

"New Orleans is the highway to the far west of America," proclaimed the text. "Steamers of great size and speed run daily from it, carrying passengers at low fares thousands of miles up the Mississippi and Missouri Rivers to the rich districts of Illinois and Missouri and other Western States, in all of which land is cheap and fertile and the wages universally high." The ad closed with an equally completing argument: "The passage to New Orleans is far safer and easier than that to New York."

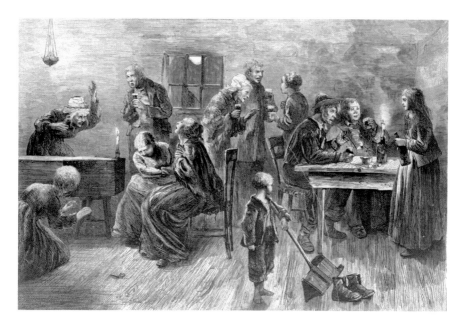

Famine pushed Irish peasants from Ireland to America in the 1840s. This "wake" acknowledged that those who left Ireland would never return. *Courtesy of the Library of Congress.*

Enough said. The *Iowa* was set to leave Ross on or about November 3, taking its passengers to a new life in a new land. What was not mentioned in the ad, but was implicit from the name of the ship and the dreams of the passengers, is the simple fact that, in addition to Missouri and Illinois, other states benefited from the exodus through New Orleans. Some Irish settled in the Crescent City itself; others moved up the river to Little Rock and St. Louis. Still others used the name of their ship as their north star. On to Iowa.

That is not to say that the Hawkeye State was a common destination for Irish immigrants in the 1840s and 1850s. In spite of the best efforts of Charles Corkery and Mathias Loras, Iowa was a frontier territory until statehood was granted December 1846, and the prospects for immediate prosperity seemed dim. In truth, the territory's greatest asset was its rich undeveloped land, but only the heartiest and most independent Irishmen chose Iowa from the start.

A variety of seemingly unrelated choices led select numbers of Irish emigrants to choose Iowa over other states. What tipped the balance toward northeast Iowa, for example, was the commitment of a confident bishop, a visionary abbot and a charismatic priest.

That bishop, of course, was Mathias Loras, who was determined to bring Catholics to his new diocese of Dubuque almost from the time of his consecration as bishop in 1837. In 1841, he initiated contact with the Irish Emigrant Society to seek its involvement in attracting the Irish to his city. Through pamphlets, advertisements and letters to editors, he championed his diocese.[13]

Coincident with Loras's initial efforts to attract emigrants to Iowa was an economic collapse that was beyond general comprehension. As a colony of the British Empire, Ireland struggled to feed its growing population in the 1830s and early 1840s. What saved the people was their beloved potato—an easily grown tuber that provided the nutrition to sustain human life. But beginning in 1845 and continuing for the next six years, a pestilence spread across the island, and the potato crop rotted in the ground. To stay in their homeland meant certain starvation and possible death. The most viable alternative was emigration, and between 1846 and 1855, nearly 1.5 million Irish sailed for America to what they hoped would be a better future.

Loras personally became aware of the famine and poverty when he visited Ireland in 1849. He wrote that he "saw many poor cottages covered with straw, and half buried in the ground and occupied by poor Catholic tenants who cultivate in the sweat of their brow small fields divided by poor green hedges or half-tumbled walls." It was clear to Loras that these poor souls would be much better off in America.[14]

But how could he draw the Irish to Iowa? Land alone would not be enough, and he understood that the opportunity to openly practice their Catholic faith would be a tipping point. In that effort, Loras met with the abbot of Mount Melleray in County Wexford to finalize plans to open a new abbey in Iowa. He would provide the land and support, and the abbot would embrace the mission.[15]

Although the monks had received other offers, it was Iowa that prevailed for an unexpected reason. It was not the location or the amount of the land that was the determining factor—it was the quality of the soil. The monks knew that the success of a new monastery would be determined by the yield of their crops. With it nutrient-rich farmland, Iowa offered the best prospects for success.

In 1848, therefore, the monks were given 600 acres of rolling prairie and timberland about twelve miles from Dubuque. The order chose to add to this stake in acquiring an additional 560 acres of adjacent land at the cost of a dollar an acre.

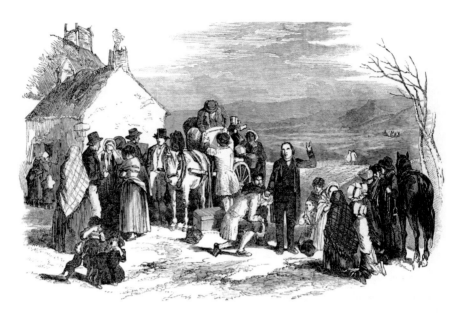

The journey to America was perilous. Here a group of Irish peasants receives a blessing from the parish priest. *Courtesy of the State Historical Society of Iowa.*

Work began quickly. Dom Bruno, the new abbot, declared that the monastery would be dedicated to the Blessed Virgin Mary and be known as Our Lady of Mount Melleray. On July 16, 1849, the abbot mapped out the location of a building some sixty by twelve feet, and work began immediately. By Christmas Day of that year, the building was ready for occupancy.

But a building and farmland did not constitute a monastery. It would take monks to work the land, and filling the ranks would be no small task. Of the sixteen monks who set out from Ireland to staff the new abbey, only ten reached Iowa. The others had succumbed to cholera on their seventy-seven-day voyage. Twenty-two others were able to reach New Melleray in January 1850, but at a price: one monk died at sea, and another abandoned his vows to become a sailor.

If you build it, they will come. That must have been on the mind of Bishop Loras as he contemplated the new monastery. He knew that the continuing famine would push the Irish out of their beloved homeland. He also knew that these devoted Catholics would be drawn to those parts of America that offered good farmland and the opportunity to openly practice their faith. Without question, Iowa—and, more specifically, Allamakee, Dubuque and Jackson Counties—offered both.

And yet these poor, uneducated Irishmen needed leadership to organize them in this long journey. Like the people of Israel in Egypt, the Irish needed a "Moses" to lead them to the Promised Land. Providence shined on Bishop Loras and on northeast Iowa in the form of a charismatic priest named Thomas Hore.

Frustrated by the famine and suffering, Hore was determined to take action. He showed immense courage to speak out against the callous insensitivity of the British government and preached sermons calling for his congregants to rise up and follow him to America. The initial plan was to settle in the new diocese of Little Rock in Arkansas, and that plan would hold throughout the long ocean journey from Liverpool to New Orleans to Little Rock that lasted from October 1850 to the end of the year.[16]

But unexpected circumstances changed his plans. First, dreaded cholera took its toll on the contingent of 450 souls, and this left many emigrants in ill health and reduced their number by 20. And on their arrival in Arkansas, these poor farmers could find no arable, affordable land. Hore and his followers had no choice but to move upriver.

And it was to Iowa they came for religious freedom and arable land. No doubt Hore had received news of the new abbey near Dubuque. As a priest from County Wexford, he was familiar with the order and with Mount Melleray. He also may have read the appeals from Bishop Loras for Catholics to come north where there was productive land at reasonable prices.

To be certain of this fact, Hore traveled to Dubuque in late January 1851. After a month of investigation and negotiation, he purchased 1,700 acres of land in Allamakee County at the prevailing price of $1.25 an acre. After completing the transaction, Hore traveled back to Fort Smith and St. Louis to gather his flock, but not all of them chose to follow him. In the end, only eighteen families chose to travel to the land that Father Hore had purchased on their behalf.

But the priest was not deterred. He bolstered his initial band of communicants with a few other Irish families who had come independently and pushed north. In March, he formally founded the colony of Wexford, Iowa, in honor of their county of origin in Ireland. And following an old Wexford tradition, he dedicated the new church on April 23—the feast of St. George, the patron saint of England.

Over the next several years, the colony emerged and matured into a community of some four hundred souls. That their faith was their anchor was without question. Hore implicitly understood the value of church institutions, and a few years after he dedicated his little parish, he invited the monks of New Melleray to open a second monastery in Wexford.

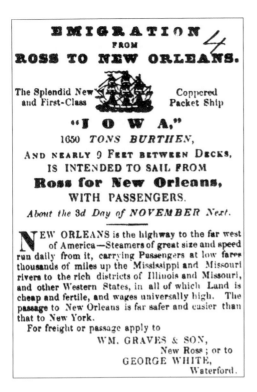

This advertisement appeared in the *Waterford Daily Mail* in 1851. Advertisements, letters and pamphlets encouraged the Irish to resettle in Iowa. *Courtesy of the British Library.*

Hore invited the prior, Father Clement Smyth, and a fellow monk to spend a week at Wexford in June 1855. Before the two men left the community, they struck a deal to open a branch of the monastery. To facilitate the establishment, Hore transferred ownership of several hundred acres of land to the order. Another transfer was completed two years later, and the order officially established its second Iowa monastery in June 1857.

With success of his Irish community seemingly assured, Father Hore made plans to return to Ireland. He departed in July 1857 and passed away in June 1864 at the age of sixty-eight.

Hore may have died, in part, of heartbreak. Within a year after his departure, the monastery at Wexford was closed, the property was sold and the monks returned to New Melleray. The Irish Catholics of Wexford were left to worship at their little church with whatever priest the bishop could send their way.

Although the Wexford settlement continued for some time thereafter, it was never the thriving community that Father Hore had planned. His departure and death combined with the failure of the second monastery were something of an Irish tragedy in Iowa.

Although Wexford was an early Irish settlement in Iowa, it was not the first, and by no means was it typical of the growth and development of the Irish people across the state. Like clusters of shamrocks, other Irish settlements appeared across the rolling prairie during the 1850s and 1860s.

The community with the claim to be the very first Irish settlement in Iowa was Garryowen in Jackson County, twenty miles southwest of Dubuque. It was established in 1838 and initially dubbed "Makokiti," an Indian name of undetermined meaning. But a wave of 100 Irish immigrants from Limerick and Cork arrived shortly thereafter, and the community became distinctly Irish in tone and temperament. Within a year, there were over 250 Irish residents, and by 1843, the number was close to 600.[17]

Community institutions emerged. In 1840, residents dedicated St. Patrick's Church, and the next year, they opened a school. In fact, it was the schoolmaster, one Dennis A. Mahony, who suggested that the name be changed from Makokiti to Garryowen. By 1850, the land around Garryowen was fully occupied—predominantly by Irish-born farmers.

Wexford and Garryowen were just two of several early examples of rural communities established by Irish immigrants in the 1850s. There was a settlement near Fort Dodge started by emigrants from County Clare. To the south near Des Moines was the "Irish Settlement." And farther west in Palo Alto County was Emmetsburg, named for the great Irish patriot Robert Emmet. All of these settlements emerged in the 1850s established by Irish people, some seeking to escape famine in the Old World and others hoping to embrace opportunity in a new land.[18]

It also must be noted that there were sizable Irish communities among the emerging cities of Iowa. For example, as early as 1846, the First Ward in the city of Dubuque was known as "Dublin" or "Little Dublin" for the large number of Irish immigrants who resided there. By 1860, about 1,800 of the city's residents were Irish-born—about 14 percent of the total population.

And Dubuque was not uniquely Irish. As might be expected, and as cities emerged along the Mississippi River and along other rivers and tributaries in the state, large numbers of Irish settlers could be found among the men who drove the wagons, laid the bricks, cut the lumber and worked in other trades. The census for Iowa in 1860 showed scores of Irish residents in Davenport, Iowa City, Des Moines and other emerging communities. Indeed, it is hard to imagine an Iowa community of any size without a few Irishmen.

This is not to say that every Irish immigrant embraced the opportunities offered in Iowa. Many stayed a few years and then moved west. Others found themselves caught up in hardship. "We all intended to follow [Father Hore]

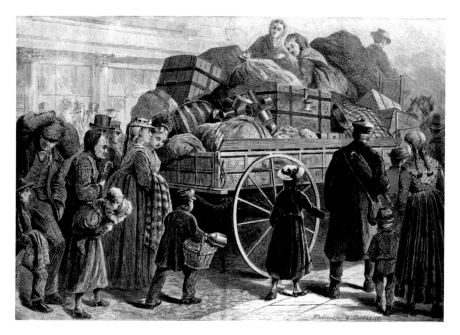

Some Irish immigrants landed in port cities but later moved on to the heartland. This image captures immigrants as they traveled to Iowa. *Courtesy of the State Historical Society of Iowa.*

and settle on a little farm and make a little home," wrote Anne Brown of Wexford in 1852, "but that desirable object is now vanished. Broken-hearted and destitute [we] saw no way for us to live [here.]...So here we are in this frozen Region without any future prospects before us. May God help us."[19] By 1855, Anne Brown was a widow living with her daughter in Dubuque. It was a touch of Irish tragedy that was not uncommon.

Yet for every story like that of Anne Brown, there were two or more stories of Irish success. These ambitious immigrants were magnets who pulled brothers, sisters and cousins from the old country to the new. And it was not peasants alone escaping famine and poverty who chose to come, but also farmers and tradesmen who could not make a living wage in the old country.

The *Burlington Hawkeye* of November 28, 1863, aptly captured the Irish immigration phenomenon in an article headlined "Ireland Coming to America." The editors observed the migratory spirit of the Irish and noted that "it will not be long before the most difficult place in the world to find an Irishman will be Ireland itself."[20]

The story further noted that the only thing holding back the tide was the price of a passenger ticket on a packet ship. "It is beyond the power of

government," concluded the editors, "of laws, of priests or politicians to do more than just lash and disturb, the great tide of emigrations."

And so they came to Iowa—pushed by oppression and famine and pulled by rich farmland and unlimited opportunity. Alex Aitkin said it bluntly, almost poetically, in a letter he sent to a friend in Ireland in January 1866. "I would rather live in Ireland if I could live as well," wrote Aitkin. "But I would not return to live in Drumnamale if Mr. Graham would make me a present of [his farm]. The land here requires no manure or drains. It will grow potatoes of the best quality without manure. There is no disease."[21]

FAITH OF OUR FATHERS

I am the good shepherd," Christ proclaims in John 10:14–16. "I know my own and my own know me, just as the Father knows me and I know the Father and I lay down my life for my sheep. And there are other sheep I have that are not of this fold and these I have to lead as well. They too will listen to my voice, and there will be one flock and one shepherd."

To be sure, this proclamation is allegory. It is also true, however, that the Catholic Church intended that the "good shepherd" be the role model for bishops in leading their dioceses and for priests in leading their parishes. In many dioceses and parishes, the role model worked particularly well. Not so in Iowa among Irish Catholics.

This is not to say that the emerging community of Irish immigrants in the Hawkeye State was anything less than committed to the faith. Indeed, almost from the time of their arrival, they began plans to build churches and find pastors.[22] And these Irish immigrants were not content to live with the occasional visit of a missionary priest. They had been persecuted for their faith in Ireland, and they yearned for a church and a pastor to minister to their spiritual needs and provide counsel on other matters when called upon. Irish Catholics saw their pastors as leaders, and no settlement could thrive without a pastor.

The Dubuque Irish, for example, were reminded of the importance of a priest when the city was struck with a cholera epidemic in the summer of 1833. Fifty deaths, many of them Irish, meant burial without the benefit of the sacraments and in ground that had not been consecrated.

Irish-born Clement Smyth became the second bishop of Iowa in 1856 and served through the Civil War. *Courtesy of the Archives Office–Archdiocese of Dubuque.*

Prayers for a pastor were answered when the bishop of St. Louis sent Father Charles J. Fitzmaurice, an Irishman, to minister to souls in the mining districts of Dubuque and Galena. Fitzmaurice encouraged and nurtured his flock and was pleased to report in July 1834 that the Dubuque Irish had purchased a lot and raised over $1,000 for the construction of a church.[23]

But not everyone was pleased with their new pastor. Fitzmaurice found himself caught up in controversy when he came to the defense of Patrick O'Connor, a man convicted of murdering a fellow miner in June 1834. As was his calling, Father Fitzmaurice heard O'Connor's confession and administered the last rites to the condemned man before he was hanged. This act of spiritual courage won the pastor no friends. Some in the community must have wondered if God had a hand in striking down Fitzmaurice in another wave of cholera that hit Dubuque in the early months of 1835.

Other Irish communities in Iowa also yearned for spiritual sustenance. The growing settlement in Davenport, downriver from Dubuque, begged for a priest to administer the sacraments. These Irish immigrants embraced the energetic Italian missionary Samuel Mazzuchelli, who traveled widely across the Iowa territory.

That the Irish of Davenport loved this unusual priest was without question. They provided him with food and shelter, even at the expense of their own needs. "It was no doubt such as this," wrote Mary Helen Carey, "that made the missionary love 'his Irish' with all their faults."[24]

The contours of Irish Catholicism in the Iowa Territory changed substantially with the coming of Bishop Loras in 1837. No longer would priests be sent to Iowa from St. Louis. It would now be the responsibility of Bishop Loras to find and assign priests to minister to the needs of his diverse flock—the Irish being the most vocal and acrimonious among other ethnic groups.[25]

Loras was no stranger to America when he arrived in Dubuque in 1839. In fact, he had served in Alabama as a college president and as the vicar-

general of the Diocese of Mobile. What surprised the new bishop, however, was the impatience and independence of his flock—most of whom were Irish-born. He knew that he faced a challenge in winning their trust.

And the task would be difficult because the Irish were suspicious of the ethnic loyalties of their new bishop. The Irish had been the first Catholics to arrive in Dubuque, and they had raised the money to build the church. To their thinking, it was their building. Not surprisingly, Loras had other views.

Adding to the tension were communication difficulties and cultural differences. In spite of having lived in America for a decade, Loras struggled with the English language and in understanding the thick Irish dialect of his parishioners. Perhaps more of a concern was the fact that Loras was a champion of the temperance movement and worked tirelessly to convince both German and Irish Catholics to abstain from alcoholic drink.

The problems became increasingly worse over the next five years, and by 1844, the Irish refused to contribute financially to the welfare of the diocese. So angry was Loras that he left Dubuque and took up residence in Burlington, then the territorial capital. He sent Father John Healy, an Irish-born missionary priest, to Dubuque to smooth troubled waters. Unfortunately for Loras, Healy joined in common cause with the fractious Irish Catholics, and the bishop was forced to return to quell the rebellion and dismiss Healy. Order was restored—with occasional flare-ups over the employment of Irish teachers in the schools and the assignment of Irish priests to the parishes.

One bright spot amid this tension came in 1843, when Loras convinced Sister Mary Frances Clarke, then of the Third Order of St. Francis, to move from Philadelphia to Dubuque. Loras had intended for Clarke and her sisters to minister to the needs of Native Americans. The need was so great for Irish-born teaching sisters, however, that Clarke revised her charism to serve the Irish immigrant communities in Iowa, Wisconsin and Illinois.[26]

Under Clarke's quiet, unassuming leadership, the new order took the name Sisters of Charity of the Blessed Virgin Mary, or BVM Sisters for short, and built a motherhouse eight miles west of Dubuque. Over the next four decades, Clarke and her sisters became a dominant force in the education of Irish Catholic children in Iowa and across the Midwest.

Even in the midst of all the tension, Loras never gave up on the Irish or his dream of having them migrate to Iowa. Almost from the start, and even during the worst of his conflicts with the laity, he was writing letters to Catholic newspapers inviting Irish emigrants to his new diocese. He was tireless in his efforts to establish a monastery of Irish monks at New

John Hennessy succeeded Clement Smyth and served until 1900. In 1893, Hennessy became the first archbishop of Dubuque. *Courtesy of the Archives Office–Archdiocese of Dubuque.*

Melleray and never stopped recruiting Irish priests and seminarians to join him in Iowa.

As late as 1856, Loras sent a representative east to a national convention on Irish emigration to make new contacts. The following year, he sent Father Jeremiah Trecy to New York to lecture on the advantages of settlement in Iowa. In this latter initiative, Loras was roundly criticized by other bishops for poaching from their flocks. If effort is a valid measure, Loras was determined to bring the Irish to Iowa.[27]

And there is evidence that these efforts were successful, even if the numbers did not support the Loras dream of a Catholic Iowa. By 1850, there were significant Irish Catholic communities in Dubuque, Clinton, Davenport, Muscatine and Burlington. And thanks to the work they were doing in laying track for the railroads, Irish Catholics had made their presence known in Iowa City and Des Moines and points farther west in the new state.

Mathias Loras served his diocese until his death in February 1858. In two decades as bishop, he quarreled with his Irish congregants but never gave up on them. Perhaps it was no surprise, therefore, that his successor as bishop was Clement Smyth, an Irish-born monk who had served as prior at New Melleray. Although Smyth's tenure was short and his legacy was modest, he

could lay claim to being the first in a successive line of Irish-born and Irish American bishops of Dubuque.[28]

Indeed. "Why not take an Irishman?" was the question that was sent to Rome when the matter of a successor to Loras was first raised in 1855, and Clement Smyth was the response to that question. Unfortunately, Irish birth was not the most important quality of a good bishop, and Smyth struggled with the challenge.

It was most unfortunate that Smyth served as bishop in the aftermath of the financial panic of 1857, which limited his ability to raise funds for new parishes and social institutions. Adding to his difficulties was the onset of the Civil War in 1861, which not only pitted North against South but also proved controversial within the Irish community in Dubuque. Smyth was an ardent Union man, which put him at odds with many Irish Democrats who did not support the war.

This is not to say that Smyth was without accomplishments. Although his relations with many Irish Catholics were uneasy, they were an improvement over the conflicts that faced Bishop Loras. And during Smyth's tenure, the number of Catholics in the state continued to grow. He established eight parishes and twenty missions in eight years. Even more important, he recruited or ordained forty-six priests during those years, many of them from Ireland.

Smyth died on September 23, 1865, and was succeeded by John J. Hennessy, a native of County Limerick. Hennessy took up his duties the following year and continued as bishop and later archbishop of Dubuque for thirty-three years.[29]

Hennessy was a skilled orator and preacher, and many who knew him considered him to be charismatic. He also was a member of a class of Catholic leaders who have been dubbed "builder bishops" for their propensity for establishing parishes, schools, colleges, hospitals and other social institutions. Just as important, Hennessy was an Irishman and had an intuitive sense of what needed to be done to nurture his diocese.

It is hard to argue with statistics. During his three decades as bishop, Hennessy established hundreds of parishes and schools. He approved plans for Catholic hospitals in numerous Iowa communities, as well as the opening of St. Joseph's (now Loras) College in 1873. By the end of his tenure, there were over two hundred priests (many of them Irish) working in far-flung parishes across the state.

This is not to say that the Iowa Irish were without their conflicts during the Hennessy years—particularly when they were forced by economics to

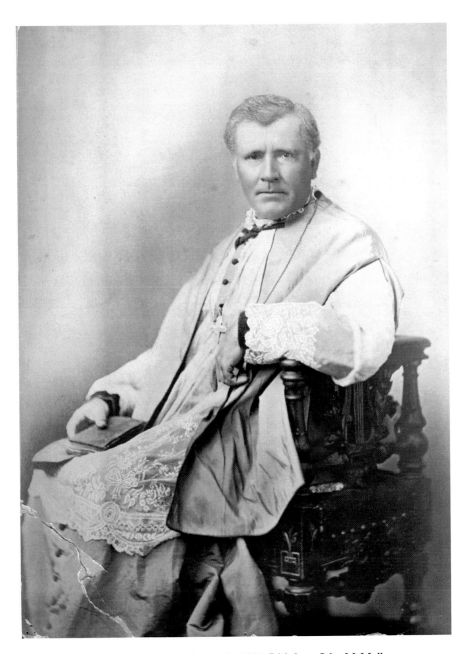

The Vatican divided Iowa into two dioceses in 1881. Irish-born John McMullen was selected as the first bishop of Davenport. *Courtesy of the Special Collections Department of the St. Ambrose University Library.*

share a worship space with Catholics of other ethnicities. It was not unusual for a small number of Irish Catholics in a particular Iowa community to petition the bishop to establish a parish only to learn that all Catholics—German as well as Irish—would share that one church.

That was the case in Iowa City, for example, when the Irish grudgingly collaborated with the Germans to consecrate St. Mary's Catholic Church in 1869. To make the task of fundraising and worship more palatable for both groups, the statuary in the church was divided, with German saints to the left and Irish saints to the right of the main aisle. To this day, St. Boniface, the patron saint of Germans, and St. Patrick, the patron saint of the Irish, share the sanctuary at St. Mary's in Iowa City.[30]

This rapprochement might seem amusing today, but it had serious consequences for the Irish of Iowa City. The number of Irish in the city continued to grow as the economy of the city expanded. With larger numbers, Irish leaders petitioned Bishop Hennessy to establish a second parish in the city—one dedicated to St. Patrick. The bishop agreed, and in 1872, the new parish opened less than a mile from St. Mary's. The Irish of Iowa City finally had their own worship space, and St. Mary's became known as the "German church."

Throughout his tenure, Hennessy devoted a considerable amount of time to expanding the presence of the Catholic Church across the state. There were Irish communities in a scattering of counties in the interior, and the number and size of these communities—most either Irish or German—grew exponentially as farmland was cultivated and railroad lines were extended.

In addition to the establishment of Irish parishes in the northeast quadrant of the state, Hennessy approved the construction of churches on the banks of the Little Sioux River, in the growing community of Emmetsburg, in the Irish settlement at Ida Grove and at Marcus, Duncombe, Shaller, Ellendale, Estherville, Lohrville, Sioux Rapids, Churden, Clare, Moville, Akron and many other communities across the state. Dedicated to saints such as Patrick, Bridget and Columbkille, it seemed that Irish parishes sprang up like shamrocks on the prairie in the last three decades of the nineteenth century.

There is no question that the growth and expansion of Catholicism in Iowa led the Vatican in 1881 to divide the state into two dioceses, with Dubuque representing the northern half of the state and a new Diocese of Davenport representing the southern half. To lead Davenport, the pope selected John McMullen, an Irish-born priest from Chicago, thereby continuing the pattern of appointing the Irish to positions of church leadership.[31]

Although he was a man of substantial vision and ambition, McMullen lasted only two years as bishop before his untimely death. Selected in May 1881, he died on the Fourth of July 1883 at the age of fifty-one. To succeed McMullen, the Vatican chose another priest of Irish American heritage, Henry Cosgrove, who would serve as bishop for more than two decades.

The number of Catholics in the state would continue to grow, as would the need for additional dioceses, as the twentieth century approached. The first step was to elevate Dubuque to the status of an archdiocese in 1893. This action was followed little more than a decade later with the establishment of the Diocese of Sioux City in 1907 and the Diocese of Des Moines in 1911. The bishops of these four dioceses were of predominantly Irish heritage.

Even though these bishops were the most visible leaders of the Irish in Iowa, the importance of parish pastors should not be overlooked in the everyday life of Irish communities in Iowa. In fact, these pastors not only were the spiritual representatives of the Church, but they also served as counselors for the temporal elements of community life. Along with elected leaders, parish priests determined the direction of their respective communities.

In 1903, Dubuque Catholics celebrated the twenty-fifth anniversary of the consecration of Archbishop John Keane, who had succeeded Archbishop Hennessy. *Courtesy of the Archives Office–Archdiocese of Dubuque.*

So also, these Irish priests were often the points of contact between the laity and the homeland of their birth. Funds would be raised to send these pastors to Ireland to visit and assess the old country. They would gather news and make observations on the state of the Irish economy and efforts to win greater independence from England.

So it is no surprise that the return of these pastors was big news in the state's Catholic newspaper, the *Catholic Messenger*. This was particularly true in the first three decades of the twentieth century. The paper would report what the pastors had seen and also provide extensive coverage on the lectures presented in their own and adjoining parishes. "Ireland Thrives Under Free State Government Says Father O'Connor" was one typical headline, along with "Local Priest on His Sixth Visit Finds Country Prospering." This message must have given comfort to Iowans of Irish heritage who might have been concerned about friends and family in the old country.

The historian Jay P. Dolan reminds us of the importance of religious faith in the identity of Irish Americans in Iowa, as well as across the nation. In fact, Dolan notes that Irish traditions and Catholic liturgy were intertwined to make the de facto version of the Catholic faith in this country. Other ethnic groups deferred to the Irish on matters of religious practice.

To be Irish was to be Catholic, or so many people believed. "In promoting this model," adds Dolan, "Catholics were building a strong fortress community that encouraged a cultural enclave, separate from other ethnic and religious groups. The key institution within this enclave was the parish."[32]

The faith of their fathers—the generations before them—defined the Irish in Iowa. They found comfort, consolation and identity in the well-worn pews of their parish church. As was well said in the words of the historian Oscar Handlin: "Struggling against heavy odds to save something of the old ways, the immigrants directed into their faith the whole weight of their longing to be connected with the past."[33]

SISTERS OF ERIN

It must have come as a surprise to many when Ellen Sullivan died in Dubuque in 1860 at the age of thirty-five. It was a tragedy, of course, her dying so young and a widow as well. The surprise was in the fact that she was worth more than $50,000, a huge sum for any Iowan in 1860 and even more so for an Irish American. There was no question that Ellen Sullivan was a woman of means.[34]

Irish American women get short shrift in any discussion of Iowa history. This is ironic because the number of Irish women who immigrated to Iowa in the years before 1860 exceeded the number of Irish men. And just as important, many of these women were entrepreneurs who made an impact on the emerging communities along the Mississippi River.

Take, for example, the city of Dubuque in 1860, the same year that Ellen Sullivan died. In that year, about 14 percent, or 1,800 residents, reported to the census that they had been born in Ireland. Of that number, 317 were single women and 183 were single men. More than half (992) were married couples, but the plain fact is that the number of Irish women outnumbered the men in a rough-and-tumble frontier town.

These single women engaged in a variety of professions. The majority (196) were servants. "Domestic work was the Irish female immigrant's preferred job," notes historian Hasia Diner in her book *Erin's Daughters in America*.[35] And why not? These girls and women spoke the language and understood their employers' expectations. The work was cleaner and less dangerous than most trades and offered a view of the opulent life among the Protestant elites.

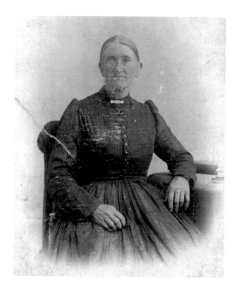

This hardworking Irish farm wife was grandmother of the proprietor of Donnelly's, a popular tavern in Iowa City. *Courtesy of Kenneth Donnelly and the Donnelly family.*

Other women—widows like Ellen Sullivan—worked as washwomen, housekeepers, seamstresses and dressmakers. A few of them worked in or operated boardinghouses. It is important to note that the census did not record any of these women in the two professions that would later be thought of as women's work: teaching and nursing.

This pattern of employment in Dubuque in 1860 was a glimpse into a larger experience across Iowa and the nation. The willingness of these women to defer marriage and motherhood—which would exclude them from employment outside the home or farm—is an indication that Irish American women often had ambitions beyond the limits of nineteenth-century American society.

Diner stresses an important point in her book: Irish women were not so much victims as they were risk takers with a desire for a better life than that offered in Ireland. "Irish women immigrated in huge numbers to the United States," she adds, "because of the greater opportunities that awaited them. Irish women migrated not as depressed survivors of Famine, but in the main they made the journey with optimism, in a forward looking assessment that in America they could achieve a status that they never could at home."[36]

Ambition and optimism also attracted Irish women and men to Iowa. Not surprisingly, many of the men sought to purchase the rich farmland that they had read about in the handbills sent to Europe. The women, however, did not always embrace the idea of joining the men as wives and mothers on the frontier. As Diner notes, women faced numerous potential tragedies through the blessed sacrament of marriage: spousal abuse, pregnancy, childcare and widowhood, to name only four potential challenges. It was not surprising, therefore, that many Irish women put off marriage as long as possible.[37]

And for the women who did accept their husbands' dreams of becoming farmers, there was more hard work than they ever imagined. There was a popular notion among many in the nineteenth century that farm life

was idyllic and that the wife's role was to maintain a home for her farmer-husband and raise their children while he toiled in the fields.

This was a false notion, to say the least. Irish American farm women devoted only a modest amount of their time to domestic chores. The majority of the time and funds available on any farm were devoted to raising crops and livestock. To say that farming was labor and capital intensive is an understatement. It was common to find women working in tandem with their husbands in planting and harvesting crops, as well as in raising hogs and chickens.

That certainly was the case in Palo Alto County in the central region of the state when seven Irish families arrived in 1856. They had journeyed by wagon from Dubuque with the dream of a homestead.[38] Settling on land near Medium Lake, the men set about building log cabins with clay floors and sod roofs. Their wives and even their children joined in planting crops and constructing outbuildings to protect the animals and prepare for winter. Several more families joined the settlement the following year.

With the prospects for additional arrivals, land speculators selected a site for a town on the shore of the lake. To attract more Irish settlers, the speculators dubbed their new community Emmetsburg in honor of the great Irish patriot Robert Emmet. Residents soon constructed a courthouse, a livery stable and a post office. The town was later moved to its current location, but the name was retained.[39]

Much of the hard work fell to the women of Emmetsburg. It must be acknowledged that much of the work in the fields was done by men and boys, but there was no shortage of other work for the women and girls. "Washing was done on a board," remembered one Emmetsburg woman of her childhood, "and cooking was done on an iron cook stove."[40]

Food was always a great concern, not just for the Irish but for all settlers on the frontier. "When mother would run out of flour," she recalled, "she would grind corn, sift it and make a course [sic] Johnny cake.… When the coffee supply ran low, mother

Mary Ryan Kelly traveled from Ireland to Iowa to find a better life. She and her husband, Patrick, farmed in Benton County. *Courtesy of Kenneth Donnelly and the Donnelly family.*

would make coffee from toast, out of real dry bread." And bread became a staple of daily life. "We baked all our own bread," she added, "baking over 30 loaves a week."

Life as it was for Irish women in Emmetsburg was replicated by wives and daughters in other Irish settlements across the state and the nation. There was no easy way to build a new life. That having been said, few women regretted the life they had abandoned in Ireland or the large cities of the eastern United States. Iowa offered opportunity for the Irish, and the women embraced that experience. The stories of that achievement are an underappreciated legacy of the Irish influence in Iowa.

Also underappreciated are the contributions of a large cadre of Irish-born women in Iowa who had no children of their own but assumed responsibility for the care and education of successive generations of young Catholics. The compassion of two orders of women religious—the Sisters of Charity of the Blessed Virgin Mary (BVM) and the Sisters of Mercy—were exceptional.

Hasia Diner makes this point very clear in *Erin's Daughters in America*. "These orders of nuns, which attracted many Irish to their ranks," noted Diner, "worked among Irish women in America and confirmed Irish values that viewed as central a woman's economic function and saw the salvation of souls and the eradication of poverty as inseparable goals."[41]

In fact, it is hard to measure the impact of these sisters on the tens of thousands of children who attended Iowa's parochial schools or on the untold numbers of Iowans who received care in hospitals administered by the Sisters of Mercy.

The BVM sisters came to Iowa in 1843 in response to an invitation from Bishop Loras to establish a motherhouse on land near the city of Dubuque. This invitation was part of Loras's grand vision to provide religious support to the growing number of Irish families in the new diocese.[42]

The road to Dubuque was a rocky one for the new order. The BVM sisters had been established in the 1830s in Philadelphia by Mary Frances Clarke, Mary Mann, Catherine Byrne, Rose O'Toole and Elizabeth Kelly. All had been born in Ireland, and all were professed and had faced substantial challenges in getting from Ireland to America.

The five women had met as members of the Third Order of St. Francis, a congregation of religious women. They brought varied life experiences to the Franciscans. Clarke had been a bookkeeper, and Mann was a milliner. Byrne was a surgical nurse, and O'Toole ran a boardinghouse. Kelly had been a volunteer healthcare worker before entering the order.

The women rented a cottage in the suburbs of Dublin, where they operated a school, Miss Clarke's Seminary. Seeking broader opportunities, the women accepted an invitation to migrate to Philadelphia to teach Irish American children.

Although they had collected sufficient funds to support themselves, they accidentally lost all of their money as they disembarked in New York on August 31, 1833. Impoverished, they traveled on to Philadelphia, where they were befriended by Father Terence Donaghoe, a local parish priest. Donaghoe became their spiritual director and assisted them in planning their new religious order.

The sisters spent the next decade in Philadelphia working among the Irish population of that city. But the growing hostility toward the Catholic Church in general and professed religious in particular led the sisters to accept the invitation to move west to Iowa.

The five founders of the order were joined by fourteen more sisters when they journeyed to Dubuque in 1843. They opened a school almost immediately, and within three years, they had constructed a motherhouse about eight miles from the city of Dubuque. The order grew in numbers and

These Irish American sisters established St. Agatha's Academy in Iowa City in the 1860s. *Courtesy of the State Historical Society of Iowa.*

prospered, and by the early 1850s, it had grown to more than forty members. Virtually all of these women were either Irish-born or of Irish heritage. Not surprisingly, therefore, these women never forgot their roots, and they were deeply concerned about the news of widespread famine in the old country.

They hungered for news. "A day of anxiety for me," wrote Mother Clarke in February 1851. "No letter—resolved with the help of God to be more resigned and bear with patience all things as if I did not feel."[43] But these sisters were as human as any other group of immigrant women; they never forgot their loved ones in Mother Ireland.

There was little time for loneliness, however. Like all pioneer women, the sisters had to provide for their own temporal needs as well as provide for others in need. Although the sisters had been raised in Irish cities, they had to quickly learn the life and responsibilities of all women on the frontier. They had to plant crops, raise pigs, milk cows and bake bread, among other daily chores. In fact, the sisters became so good at these tasks that the priests and seminarians of the diocese became dependent on the sisters for clean clothes and fresh bread. Good work led to new tasks as the monks of New Melleray also asked the sisters to mend their socks and cassocks. Mother Clarke and her sisters accepted these chores with silence and acquiescence.

The diverse work of these Irish sisters was a reflection of their values as women of the frontier. They worked hard, they were pragmatic, they were thrifty and self-reliant, they were cooperative and generous and they embraced both freedom and equality. These were values that served as the foundation for their charism and their curricula.

Unfortunately for the sisters—as was true for women in general in the nineteenth century—they were not treated as equals. Indeed, there was a condescending attitude in almost all the communications with and about the sisters. They were perceived almost as if they were children, not an order of educators.

Typical of this attitude is an 1845 report from the vicar general of Dubuque to Bishop Loras. "The Sisters are happy," wrote Father Cretin. "It proves how good they are and it is this goodness, this simplicity that I admire in them and that can do very much to make their establishment effective for the good of the diocese. I have confidence that this house will one day be your greatest consolation."[44] To be sure, Cretin was complimentary to the sisters, but condescension is evident in his prose.

So also was the attitude of Father Donaghoe, who might have known better. It would not be wrong to think of him as a patriarch of the order. In fact, it is likely that he saw himself that way. "He called the sisters his

'children' and often treated them as such," notes historian Mary DeCock. "Mother Clarke assumed a typical 'mother role' to match his 'father role.'"[45] In this capacity, Donaghoe not only guided the sisters in their spiritual development but also controlled their temporal welfare. Mother Clarke did maintain the accounts for the order, but it was Donaghoe who made all financial decisions. This is not to say that Donaghoe distrusted Clarke or her sisters; he was a man of his times, and he could not fathom the possibility that women could care for themselves.

It is important to note that Clarke did not rebel against Donaghoe's rules. She quietly accepted them until he passed in 1869. But very soon after the priest was buried, Clarke had the congregation incorporated under Iowa law and instituted the process of receiving formal Vatican approval. She persisted in this quest for the next fifteen years until she received papal approval of the order's constitution in 1885. She was to remain superior general of the order for the rest of her life.

Mother Clarke and her congregation of sister teachers were not alone in servicing the needs of the Irish community in Iowa and across the Midwest. In fact, in the very year that the BVM sisters came to Iowa, a delegation of the Sisters of Mercy arrived in America from Ireland. Their twin missions were the education of young women and care for those in need.

The Irish sisters spread west across the country and established themselves in many cities in the Midwest over the next two decades. They continued to establish schools and hospitals as requested by grateful bishops. In fact, the first hospital in Chicago was opened by the Mercy sisters in 1846. It serves that city to this day.

The order moved farther west in the years after the Civil War as the number of Irish and Catholic immigrants arrived in this country and called for their services. It was in 1869 that a small group of these sisters settled in Iowa after learning that many Irish Catholics were sick and in need of direct assistance. Led by Mother Mary Borromeo Johnson, the sisters embraced this calling in Davenport. From these roots would come the multiple Mercy hospitals across the state.

Mother Borromeo quickly articulated to public officials in Scott County her vision for assisting citizens in need for healthcare without regard to their religious affiliation. "Our main object," she stated boldly, "will be the relief of suffering in all its forms—not as an object of speculation or for a profit, but that it may prove a general public benefit."[46]

That Mother Borromeo was a strong, articulate and compassionate Irish woman gained substantial notice in this frontier river city. Although

The Sisters of Mercy established hospitals across the state. This is the first Mercy Hospital building in Iowa City. *Courtesy of the State Historical Society of Iowa.*

she stayed in Davenport for only seven years, she made quite an impact. "She knows how to deal with men" was a common description of Mother Borromeo.[47]

In 1873, as some Mercy sister began a campaign to expand needed facilities in Davenport, other sisters boarded a train to Iowa City. Once again, these Irish-born nuns were responding to a healthcare challenge— this time a request from Dr. W.F. Peck, the dean of the new medical school at the University of Iowa. Peck had called on the order to establish facilities in Iowa City to assist a wide variety of patients.[48]

The Iowa City contingent was led by Mother Mary Catherine Slattery, a native of Ireland, who stayed until 1880, when she moved on to establish the Mercy Sisters in Fort Dodge. She was succeeded by Mother Mary Isadore, who had come to Iowa in 1869 and had established the Mercy sisters in Independence and Cedar Rapids before coming to Iowa City. She would remain in Iowa City until her death in 1899.

The impact of these Irish-born women was substantial and is a sizable element in the foundation of healthcare in Iowa. In like manner, the Mercy sisters contributed to the growth of educational opportunities for young women to receive an education at all levels from elementary instruction to post-collegiate training.

The role of Irish women in Iowa has too often been neglected. The cause, in part, is the dominance of men in the expansion of the Catholic Church in the state and across the nation. Irish women were sublimated in the social structures of both secular society and in the life of the Church. And yet these women—farm wives and professed religious alike—remained strong. "Irish women," notes Diner, "viewed themselves as self-sufficient beings with economic roles to play in their families and communities."[49] Their contributions shared the contours of the life of the Irish in Iowa.

CITY SLICKERS

L ittle Dublin"—that's what the residents of Dubuque's First Ward called their neighborhood. It was an appropriate nickname since the majority of the residents had been born in Ireland, even if only a few of them had ever lived in Dublin.

So why did the First Ward have such an iconic nickname? The simple answer is that the density of the Irish-born living in this one neighborhood underscored the fact that the majority of the Irish in Iowa lived in cities.

There is irony in settlement pattern because the majority of the Irish who immigrated to Iowa had rural roots. For generations, they had scratched out meager livings as tenant farmers growing grain for export and potatoes for domestic consumption. When the potatoes turned black and famine swept the island, many farmers chose to leave for America.

One might assume that tenant farmers from Ireland, who had no education or job skills, would seek employment as farmhands. Those who were a bit more prosperous purchased homesteads and farms of their own. And there were many Irish farmers who arrived in this country and followed that path.

But the vast majority of Irish immigrants arrived in the big port cities and never left. They knew the language and understood the political system and found employment in the building trades, in the civil service and in occupations that supported the growing number of their fellow countrymen who arrived each day. Quickly, the former tenant farmers became city slickers.

Even the Irish who came to Iowa could not resist the lure of the cities. Without question, the number of Irish in Dubuque, Davenport and other river communities was small relative to the number in the big cities of the East and the Midwest. But as a percentage of all the Irish in the state, the urban Irish prevailed, and the percentages only increased as the Irish spread west across the state to Iowa City, Des Moines, Sioux City and other communities.

The urban experience in Iowa was not unique to the Irish. In fact, all of the immigrants who arrived in one of the river cities needed to find places to live, jobs to provide for their economic welfare, churches to offer a way to pray to God, schools to educate their children and halls and taverns that provided space for social and political gatherings. These needs defined the world of urban immigrants in Iowa and across the nation.

Shelter was the first requirement of most of these Irish arrivals. Not surprisingly, they tended to cluster in specific neighborhoods with their fellow countrymen. As one might expect, these areas were identified with the adjective "Irish" to specify the ethnicity of their residents. The quality of their homes was shabby at best, but the urban Irish would rather live with their kin than venture out among the Anglo-American majority.

Next on the list was work. Each Irishman who arrived in Iowa was left to fend for himself and his family. Each one mustered his talents and did his best to find work. Typically, the first job an Irishman found was as a day laborer. Some with special skills were employed as masons and carpenters, and others were miners and draymen. A few were shopkeepers, shoemakers and tailors. Women often found employment as servants.

The urban Irish also placed great stock in establishing ties to their parish churches. It was comforting to know that you could always go to a priest for advice or assistance. It was important, therefore, that these priests be Irish-born or of Irish heritage. So also, Irish American parents wanted their children to be taught by professed women religious who shared their common heritage through parochial education.

Beyond the basic needs for shelter, work and worship, the urban Irishman needed places to relax. Saloons and taverns were ubiquitous in every Irish neighborhood. They were the poor man's social club, where an Irish worker could enjoy a pint or two before returning home. It was the place where news and opinions were exchanged and where protests were organized.

In like manner, these urban communities often had social halls where Irish orators and local leaders would opine on the latest dispatches from Ireland and call for more action against the heinous policies of the British

The Irish of Iowa City made their presence known with the construction of St. Patrick's Church in 1879. *Photo from the Paul Juhl Collection at the State Historical Society of Iowa.*

government. Notable in Iowa were the Hibernian Hall in Davenport and Foster's Hall in Des Moines, where traveling speakers would educate and inform the Irish of Iowa on what they could do in defense of Mother Ireland.

Although these elements were common to the Irish experience in Iowa cities, there were some unique aspects to Irish life in these cities. The arc of those experiences was determined in part by the respective size of each Irish community and the personalities of the individuals who led those communities. As with politics, some characteristics of Irish life in Iowa's cities were local.

If any city could lay claim to being the capital of Irish Iowa, it was Dubuque. As one of the oldest cities in the state and the earliest to welcome the famine Irish in the 1840s, the city took on an Irish cast quite quickly.[50]

The contours of Irish life in Dubuque were laid down by Judge Charles Corkery. As was the case with so many early urban leaders, Corkery was a booster and looked for every possible way to attract more of his countrymen to his adopted city.[51] Little is known about his origins other than his Irish heritage. He served Dubuque in numerous capacities, including as probate judge, postmaster and president of the St. Vincent de Paul Society, among other leadership positions. Perhaps more important, he was a close confidant to Bishop Loras and Father Donoghue, giving both of these clerics a better sense of the mind of the Irish layman.

Corkery was succeeded as the leader of the Dubuque Irish by the infamous Dennis Mahony, also a booster and, more important, the editor and publisher of the *Dubuque Herald*. Like Corkery, Mahony took on numerous roles. He was a schoolteacher, postmaster, justice of the peace and state legislator, all before he became a newspaper publisher.[52]

That he was an ardent patriot was without a doubt, but Mahony was also a vocal critic of the Lincoln administration and the president's conduct of the Civil War. He would eventually serve three months in federal prison for his controversial views.[53]

Mahony's informal responsibilities as leader of the Dubuque Irish were passed to a man who shared the controversial editor's considerable communication skills. John Hennessy was consecrated as the third bishop of Dubuque in November 1866, shortly after Mahony had been elected sheriff. Hennessy received deference by virtue of his office, but in time, he would also earn the respect of the Irish Catholic community.

Born in County Limerick in 1825, Hennessy served as bishop and later archbishop of Dubuque until 1900. For fifteen years, he nurtured Catholicism in the entire state. This changed in 1881, when Davenport became a diocese and episcopal responsibilities were divided along county lines.

By the end of Hennessy's tenure, the number of churches, schools, priests and nuns in the archdiocese numbered in the hundreds. These achievements were a credit to the archbishop's steady role as a cultural chieftain as much as it was his responsibilities as the leader of the Church in Iowa.[54]

The life of the Irish in Davenport was much the same as it was for their fellow countrymen in Dubuque. As it was to the north, the Irish in Davenport congregated in a single neighborhood in and around Hibernian Hall, their impressive if informal community center. The hall was the

culmination of forty years of a gradual growth in numbers among the Irish in Davenport.

One might claim that the Irish were in the thick of the leadership circle in Iowa from the time it was established as a territory. In fact, the first Irishman in Davenport was William B. Conway, who had been appointed territorial secretary by President Martin Van Buren. Conway arrived in the city in July 1838.[55]

Conway was something of an impulsive individual and assumed the power of "acting governor" in the absence of Robert Lucas, the new territorial governor. Using disputable authority, Conway declared Davenport to be the new territorial capital. When he heard the news, Lucas was furious and moved the capital to Burlington. The two men remained at loggerheads until the tension came to an end with Conway's untimely death of typhoid fever. Not surprisingly, he was both mourned and lionized by the citizens of Davenport.

Other Irish Davenporters were active Democrats, a fact of city life that did not please the editors of the *Daily Gazette*, a Republican paper. After

The Irish of Iowa City gathered at T.J. Kenney's tavern for a pint or two and to discuss the issues of the day. *Courtesy of Kenneth Donnelly and the Donnelly family.*

a particularly bitter election loss in 1854, the *Gazette* had this observation: "This city contains all kinds of people and from all nations of the human race and some that are scarcely human, among whom are some of the wild red-mouthed Irish with hair on their teeth that are a pest to society."[56]

That there were patriots among the Irish in Davenport was evident in the arrival and work of Thomas McCullough and his wife, Elizabeth Dorney. Both McCulloughs had been born in Ireland and had suffered through the famine. They married in 1854 at Old St. Patrick's Cathedral in New York and came west to Davenport in 1859.[57]

The McCulloughs wore their love of Ireland on their sleeves, and together they were leaders of the American Fenian Society. Over the next several decades, they brought numerous orators to the city to raise aid for Ireland. The McCulloughs also established social institutions and organizations for the benefit of the Irish in Davenport.

The McCulloughs passed on their informal roles as leaders of the Irish community in Davenport to two men, Michael V. Gannon and Thomas L. Sharon. It was in their shared passion for Ireland that Gannon and Sharon would give Davenport a distinct Irish identity.

Gannon was the oldest and most visible of the two leaders. Born in Dublin in 1846, he immigrated to the United States and Davenport shortly after the Civil War. He worked as a journalist as he studied law and was admitted to the Iowa bar in 1873. He went on to serve on the city council and as district attorney before leaving the city in 1887 for work in Nebraska and then Illinois.[58]

It was during the 1890s that Gannon rose to national prominence as president of the Irish Land League and later the Ancient Order of Hibernians. He returned to Davenport in 1905 to practice law with A.P. McGuirk and remained a fixture in the city until his death in March 1926.

Throughout his professional life, Gannon was active and vocal in presenting the Irish cause, and he delivered numerous lectures that made the case for Irish independence. It was a rare St. Patrick's Day that passed in Davenport without remarks from Michael Gannon.

In tandem with Gannon was Thomas L. Sharon, who was ten years Gannon's junior and never quite achieved the fame and notoriety of his comrade in arms. Like Gannon, Sharon was a journalist. In fact, the two men were the founders of the first two Catholic newspapers in the state. For Gannon, journalism was one stop on his way to national politics. For Sharon, newspapers were the zenith of his career.[59]

Sharon was the founder, publisher and editor of the *Iowa Messenger* from January 1, 1883, until his death in June 1888. The paper was committed to

sharing news of the Catholic Church and the work of the Ancient Order of Hibernians with its Iowa readers. Joining him in the endeavor were his siblings: Emmet, who was the former city attorney; Fred, the former city postmaster; and Minnie, who served as the city editor. Together, the Sharons put out an impressive hybrid of a newspaper that reached across the state and is still published today as the *Catholic Messenger*, the weekly newspaper of the Diocese of Davenport.

The early growth among the Irish people in Iowa came in the river cities, from Dubuque to Davenport and Muscatine to Burlington. But westward expansion was inevitable as the railroad pushed relentlessly across the new state. And it was the Irish who embraced the iron horse as they eagerly sought employment in laying track and working as engineers and train agents.

As the track was laid, new cities grew in the heartland; Iowa City, Cedar Rapids and Des Moines were early beneficiaries. There were sizable Irish communities in all three cities. In the 1860 and 1870s, the western half of the state was cultivated and settled, and the Irish could be found in numbers in Fort Dodge, Council Bluffs and Sioux City.

It was in the capital city of Des Moines that the Irish made a significant impact, first in the 1860s and for the remaining decades of the century. Perhaps most surprising was the early leadership roles garnered by the Irish. Note, for example, one Thomas Cavanagh, a Galway native who had come to the United States in the famine years and prospered as the owner of more than 1,500 acres in no fewer than nine counties. He eventually moved to Des Moines, where he was elected mayor in 1862.[60]

Another example of a swift rise to power in the capital was Henry O'Connor, a Dublin native who first settled in Muscatine in 1849 and eventually served with distinction in Company A of the First Iowa Infantry during the Civil War. His war record led to his appointment in 1867 as attorney general of Iowa, and eventually he moved on to the national political stage as a member of the Grant administration.[61]

But the Irish leadership caste in Des Moines was dominated by clergy in the form of two dynamic pastors: Father John F. Brazill and Monsignor Michael Flavin. These two men served as something of Catholic chieftains of Des Moines, each in his own time. Both were instrumental in the establishment of St. Ambrose Cathedral, the mother parish in Des Moines that was dominated by its Irish congregants.

Father Brazill was a native of County Clare who came in the 1850s to Dubuque, where he came under the direction of Bishop Clement Smyth. Seeking to establish the Church in the western part of the state, Smyth sent

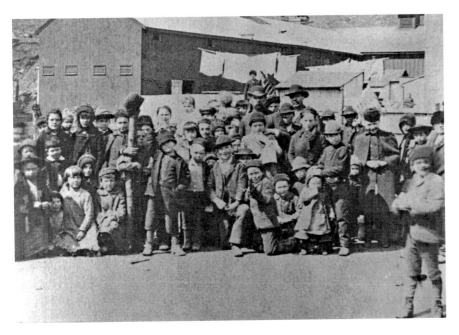

Irish families were large, and often the children played in the streets. These "urchins" pose on Dodge Street in Dubuque in the 1880s. *Courtesy of the Center for Dubuque History.*

Brazill to Des Moines in 1860 as the resident pastor in that city. Sensing also that Brazill had real leadership potential, the bishop appointed him as vicar general for the diocese. He remained vicar general until 1881 and continued as pastor until his death in 1885.[62]

Brazill was a leader of considerable strengths and weaknesses. He was a gifted communicator who delivered legendary speeches and sermons. He also had the natural instincts of a politician and had many friendships among state and city officials. And yet Brazill was a poor financial manager and was often one step ahead of his creditors. He was much beloved in Des Moines, a fact reflected in his five-hour funeral attended by forty priests.

Brazill was succeeded in his role as Catholic chieftain by Monsignor Michael Flavin, a native of County Waterford who arrived in Des Moines after short tenures in Dubuque, Cedar Falls and Davenport. Flavin had been sent to the capital city to build a new church on land that had been purchased by Brazill.[63]

For the next four decades, Flavin devoted himself to the land of his birth and faith of his fathers. Indeed, Flavin was a vocal proponent of all things Irish and took frequent trips back to Ireland to assess the condition of life

there. He worked for justice and independence for the Irish as well as the Catholic Church. It can be safely argued that Michael Flavin was the face of Irish Catholicism in Des Moines until his death in 1925.

The Irish continued their push north and west across the state in the 1850s and 1860s. They settled in Polk and Madison Counties in the 1850s and then on to Fort Dodge in Webster County and Emmetsburg in Palo Alto County. Then it was on to the Missouri River in settlements at Council Bluffs and Sioux City. By the 1860s, there were Irish communities in numerous Iowa counties from river to river.

Success was not assured when the Irish settled Sioux City in 1856. Without question, the location for the community on the Iowa side of the Missouri River had potential, but the number of settlers was small, and they were generally impoverished. The struggle the Irish community faced in raising funds to build its first church was an indication of its poverty.[64]

But the Sioux City Irish were a scrappy lot and remained committed to their new location in spite of the hardship. Lumber was harvested in Nebraska and floated across the river, and the church was assembled by the parishioners themselves. Completed in the 1860s, the church became the symbol of the Irish commitment to Catholicism in northwest Iowa.

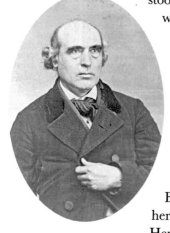

Of these early settlers, it was John Fitzgibbons who stood out. He was a native of County Limerick who immigrated to Boston in 1846. Although he easily found work in that city, he was restless to move west. His journey brought him to Sioux City, where he used his building skills to shape the community's skyline and lay the rails that took the trains across the river into the Dakotas.[65]

In 1872, the initial efforts to establish the Irish in Sioux City were codified in St. Mary's Parish under the leadership of Father B.C. Lenehan, a priest of Irish American heritage sent to Sioux City by his bishop, John Hennessy of Dubuque. Known as "Irish parish," St. Mary's was the center of the community, and Lenehan was the de facto chieftain. He would remain in that capacity until the mid-1880s.[66]

Perhaps the most dramatic moment in the history of the Irish in Sioux City came on

As editor of the *Dubuque Herald*, Dennis J. Mahony was a critic of the Lincoln administration. He was incarcerated for his views in 1862. *Courtesy of the Center for Dubuque History.*

Confirmation Sunday in 1877. Present were the pastor, Father Lenehan, and the bishop, John Hennessy. As the liturgy progressed, a rare earthquake shook the city. St. Mary's swayed and rumbled, but the pastor and the bishop remained calm and steady. It was recalled that the bishop stood "as erect and immovable as one of the round towers of his native Ireland." When the quake subsided, the bishop resumed confirming young Irish Catholics without comment.

In the last two decades of the nineteenth century, the Sioux City Irish were epitomized and perhaps led by John Brennan, a passionate orator, editor and advocate for all things Irish. Born in County Roscommon in 1845, Brennan came to the United States in 1865 and wandered west to Omaha to study law and on to Sioux City, where he became a reporter for the *Sioux City Daily Times*.[67]

Like so many urban Irishmen in Iowa, Brennan became a community activist for his adopted city. In 1875, he was elected justice of the peace and later served on the city council and as city attorney. He also continued to speak and write and was active in the national effort by Irish Americans to win independence or at least justice for the impoverished people of Ireland.

Brennan capped his career by establishing a new publication devoted to his twin passions: his nationality and his faith. The *Northwest Advocate* provided news and information on issues of concern to the Irish Catholic and English-speaking Catholic communities of northwest Iowa. Brennan's sudden death in 1900 led to the merger of the *Advocate* with the *Catholic Messenger* published by the Sharon family in Davenport.

The Irish in Iowa were largely an urban people. As was the case in other states, these immigrants had planned to settle on the land and return to raising crops and livestock. But circumstances—poverty, opportunity and even sheer chance—directed most Iowa Irish immigrants to cities such as Dubuque, Davenport, Des Moines and Sioux City, among others. And in these cities, the Irish flourished.

CHAPTER 6

COUNTRY FOLK

It was the lure of the land that drew the Irish to Iowa—an attraction that was nurtured by a cadre of true believers and speculators. Looking west across the Iowa Territory, these boosters saw a vast expanse of rich, arable land in need of settlement. Looking east across the Atlantic Ocean, they saw a growing population of potential farmers who could be encouraged to resettle in Iowa.

How could these immigrants be convinced to abandon their homeland for the New World? The Irish were in the midst of famine, and there was little future in the life of a tenant farmer. For many Irish peasants, therefore, the risks of a long ocean voyage and train trip to Iowa were far better than starvation at home.

But Iowa's pioneer generation was not willing to rely on the collapse of the Irish economy to be the sole impetus for migration to Iowa. Local land speculators understood that Iowa was in competition with other states for these immigrants. They knew that they had to promote the Hawkeye territory as a Garden of Eden where crops would grow with little effort. Land would be the lure.

To entice the Irish to come to the Hawkeye State, both earnest true believers and ambitious land speculators used a variety of publications and promotions. One of the easiest and primary tools was newspapers. Land speculators purchased advertisements in eastern newspapers touting the farming opportunities in Iowa. These efforts were enhanced by letters to editors from Irish Americans in Iowa that testified to the truth

of the advertisements. It was a potent combination that motivated thousands of Irish immigrants to seek a better life in Iowa.[68]

The editors of the *Boston Pilot*, the leading Catholic newspaper in the United States before 1860, were ardent in publishing and endorsing these letters. In fact, the *Pilot* went so far as to recommend that Irish immigrants should start walking west. "The man who does this and faces toward the setting sun," noted the *Pilot*, "will find the home he seeks at last."[69]

Edward Gillen of Dewitt wrote and reinforced what previous Iowa Irishmen had said. Just about any tradesman would do well, he stated. And the farming opportunities were extraordinary. "As for Iowa," he wrote in one letter, "…as far as I have seen, I have met nothing to surpass it."[70]

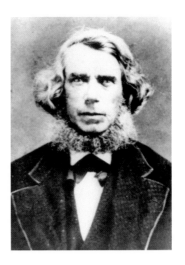

Patrick Kelly and his wife, Mary Ryan Kelly, left Ireland in the 1850s and established a farm in Benton County. *Courtesy of Kenneth Donnelly and the Donnelly family.*

Speaking dollars and sense, another Irishman wrote to the *Pilot* in 1859 of opportunities to purchase land on the cheap as the first generation of settlers moved farther west. "Farms that would have brought $50 an acre in Illinois or Iowa a year ago," he exclaimed "can be readily purchased for $15 to $20 per acre, and this is the finest farmland in the world."[71]

In addition to these letters, there also was a more structured effort to reach potential immigrants in Europe. Thousands of pamphlets were distributed across the British Isles and the European continent telling potential immigrants how they could own land and escape poverty in a wonderful place called Iowa. These pamphlets were published on a regular basis beginning in the 1830s. Albert M. Lea, for example, published *Notes on the Wisconsin Territory* in 1836; Isaac Galland authored *Galland's Immigrant* four years later; and John B. Newhall issued *Sketches of Iowa or the Emigrant's Guide* in 1841. All three urged ambitious impoverished residents of Europe to come to Iowa.

In fact, these pamphlets had their desired effect, as Iowa moved to statehood in 1846 and experienced substantial growth over the next fifteen years. The expansion of the railroads across the state led to additional opportunities for settlement, which, in turn, encouraged the state government to issue yet more appeals.

One of the most ambitious was issued in 1870. It was in that year that the Iowa Board of Immigration published sixty-five thousand copies of a pamphlet titled *Iowa: The Home for Immigrants, Being a Treatise on the Resources of Iowa and Giving Useful Information with Regard to the State, for the Benefit of Immigrants and Others*. Printed in numerous languages, this publication reached a broad audience and fueled a second wave of arrivals in the 1870s and 1880s.[72]

In addition to letters and pamphlets, the Church also endorsed the journey to Iowa. In big cities of the East and in small villages in Ireland, the clergy encouraged their flocks to consider immigration and often led bands of these poor souls on the journey. That certainly was the case for the Irish farmers who settled in and near the settlements of Wexford in Allamakee County and Garryowen in Jackson County.

And "settlement" was the operative term to describe the first Irish farming communities in Iowa. By the middle of the 1850s, several Irish settlements had emerged in the central counties in the state. There was the Reilly Settlement in Chickasaw County and other smaller clusters in Floyd, Buchanan, Blackhawk, Pocahontas, Polk, Madison, Warren, Palo Alto and Webster counties. In the years before the Civil War, the number of Irish settlements in Iowa was not large, but they were widespread across many counties.[73]

These small communities prospered, thereby fulfilling, to some extent, the promises made in the letters and pamphlets. A good example of this success was the Irish settlement that straddled Madison and Warren Counties. Between 1860 and 1870 alone, the population of this community more than doubled and the net worth of residents increased by more than fivefold.

Another example is the Irish settlement in Neola Township near the Missouri River. As the Chicago, Rock Island and Pacific Railroad pushed west across the western half of Iowa, the Irish laborers who laid the rails purchased land from their employer. The town was platted in 1871, and within three years, the settlers had organized a Catholic parish. Not surprisingly, the parish attracted more Irish settlers to the county. From fewer than twenty families in 1874, the community grew to more than one hundred families by 1882.[74]

These rural settlements provided both a lifeline and an identity for the many Irish farms that emerged within a few miles of what might be called a town. Although these farmers were not isolated, there was little daily communication among and between them. It was, however, a life of real potential if the settlers were willing to work hard. It meant building a log cabin, planting crops and then transporting those crops to town or to a

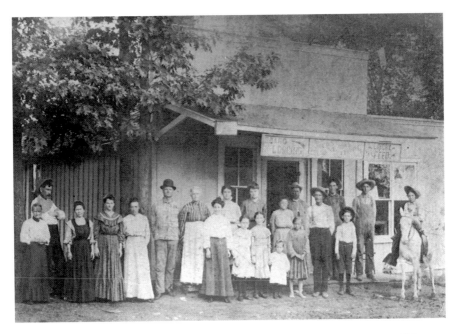

In addition to farming, the rural Irish also provided lodging for quarry workers. This boardinghouse was operated by the Gatens family. *Courtesy of Kenneth Donnelly and the Donnelly family.*

railhead for shipment to market. It often meant living without the consolation of the Catholic Church. Whether in Iowa or elsewhere across the Midwest, farming was not a vocation for those with weak constitutions or those who were not imbued with ambition, optimism and self-determination.

Take, for example, the family of Patrick and Mary Ryan Kelly, who settled on a farm in Benton County. They were natives of County Kilkenny who came to Iowa with their four oldest children in 1855. Like many of the Irish who settled Iowa, the Kellys had arrived at New Orleans in December 1853 after a six-week ocean voyage and continued their journey north.[75]

After a stay in Geneva, Illinois, where twins were born in 1854, the Kellys traveled to Benton County, where they purchased land twenty-six miles west of the boomtown of Cedar Rapids. Patrick acquired his farmland from the government for the typical price of $1.25 an acre. It was on this land that Patrick, Mary and their children would build their future.

And Benton County prospered because of the Kellys and other Irish families that settled in the area. Growth was accelerated by the arrival of the Chicago and North Western Railroad and the establishment of a small settlement dubbed Blairstown.

Travel to town—whether it was to Blairstown or Cedar Rapids—was often on foot. One of the girls, Bridget, was fond of telling her nephews and nieces of how she regularly walked the twenty-six miles back and forth to Cedar Rapids, where she worked.

And personal travel wasn't the only challenge faced by the Kelly family during the 1850s. For income, they raised wheat and hogs, and the entire family was needed to get these commodities to the mill and the market. Family members remembered hauling sacks of grain and dressed hogs by bobsled to Iowa City, the closest market town. Eventually, feed mills were erected in Marengo, a closer commute than Iowa City. The resulting flour was sold for much-needed family income.

Crop rotation added new agricultural challenges for the Kellys. By the later decades of the century, they were raising corn and oats along with the wheat and hogs on the Kelly farm. All of this was done with only a plow and horses. Most crops were sown and harvested by hand.

Although the Kellys prospered on the farm, they were deprived of the opportunity for weekly worship. Traveling priests would offer Mass from time to time, but Benton County did not have a Catholic parish until the establishment of the Church of the Holy Cross in 1866.

The Kelly family persisted season after season, year after year. At the time of their passing in the first decade of the twentieth century, Patrick and Mary could look back on more than a half century of growth and achievement both in the number and accomplishments of their children and grandchildren and the substantial farm and home they had built in Benton County. They had made it in Iowa and America after little more than a fourth-grade education in Ireland.

And the Kelly story was a common one among the Irish in Iowa. Arriving in Palo Alto County in 1858, Martin and Catherine Coonan built a cabin on the banks of the Des Moines River. Ambitious for more, Martin hauled bricks to the site and constructed a two-story dwelling that became known as a tavern and hotel for weary travelers.[76] The success of the tavern led other immigrants to join the Coonans. Additional Irish immigrants purchased adjoining land and built a store, and soon a grain and sawmill was added to the mix. By 1874, there were nearly forty buildings in the town.

The community would eventually move from the Coonan site to a more convenient location when the rail lines were laid later in the 1870s. This should not diminish the Coonan family's achievement in serving as an economic engine in an agricultural community.

Some rural Irish named their communities for Irish leaders such as Robert Emmet. This statue is in the town square in Emmetsburg, Iowa. *Courtesy of Jane Whitmore, Emmetsburg News.*

Another example of achievement among the country Irish could be found in Polk County. In 1867, Martin Flynn purchased six hundred acres of farmland for an impressive price of $16,000. He acquired an additional six hundred acres for a similar price a few years later and constructed a new home and barn.[77]

Where did Flynn acquire the funds to make these purchases? He had arrived in Iowa in 1851 without funds, but he had the good fortune to work for various railroads in construction management. Hard work and careful investment had led to an accumulation of wealth, and he invested his money in farmland. Martin Flynn had fulfilled his dream.

And yet Flynn knew that his skill in railroad work was an important supplement to his dream of being a farmer. In the 1870 census, for example, Flynn described himself as both a "railroad contractor and a farmer." Both professions would contribute to his personal prosperity.

Martin Flynn had married Ellen Keane in 1864, and together they parented ten children between 1866 and 1884. All of the children were living at home when the State of Iowa conducted a census in 1885. The farm was prosperous and productive, and the family homestead was impressive by any standard.

The Flynn home, more appropriately described as a mansion, was featured in the May 1907 issue of *Midwestern Magazine*. Today, the Flynn home and farm have been incorporated into Living History Farm, a historic site and museum dedicated to America's agricultural heritage. The legacy and achievement of Martin Flynn and his family live on in the twenty-first century.

Iowa was a state that fostered numerous Irish settlements with very little effort beyond the initial push by speculators and immigrants through letters and pamphlets. For numerous reasons, the Irish were attracted to Iowa, and all of the state's ninety-nine counties had from a few dozen to several thousand Irish settlers throughout the nineteenth century. And the descendants of these immigrants continue to nurture this Irish presence even to the present day.

It is also important to note the role that the Irish settlers in Iowa played in supporting the Irish colonization effort in Nebraska and Minnesota. As early as the 1850s, a small band of Irish settlers set forth from Garryowen to establish a new colony about twelve miles from Sioux City on the Nebraska side of the Missouri River. After several name changes, the once-Irish Iowans chose to call their settlement Jackson.[78]

The Jackson Irish became something of a prototype for future colonization efforts. In the 1870s, numerous bands of Irish immigrants passed through

Although he worked hard as a farmer and railroad worker, Michael Shelley struggled to meet his mortgage payments. *Courtesy of the State Historical Society of Iowa.*

Iowa on their way to communities named O'Connor and O'Neill, among others. Maybe the editors of the *Iowa Messenger* put it best when they claimed in 1885 that these settlements offered a form of salvation for the impoverished Irish immigrants who remained trapped in the congested cities of the East.

Perhaps the best indication of the quiet achievement of the rural Irish in Iowa was a story that appeared in the July 16, 1905 edition of the *Iowa State Register*. On page 19 was a picture of Jerry Maher and his family that noted that Maher was the "owner of the most valuable land in Iowa."[79] The *Register* went on to detail all that Maher had achieved since his arrival from Ireland. "He came to this country when a young man," noted the story, "worked out and saved his earning until he had $700, then bought a small piece of land, rented more, and kept on adding to his holdings, all the time a little in debt but all the time gaining." The editors summed it up best when they concluded that Maher "has shown what an Irish-American citizen can do in thirty years." Unstated but very evident is that Jerry Maher was not unique. Many Irish Americans achieved success in all of Iowa's ninety-nine counties.

CHAPTER 7

THEIR DAILY BREAD

"G ive us this day our daily bread" is a phrase from the Lord's Prayer
that is very familiar to all Christians. That prayer was certainly
on the minds of Irish immigrants as they disembarked from trains, boats
and wagons in their new home state. The struggle to find work to sustain
themselves and their families would consume their days.

The Irish had both advantages and disadvantages in their search for
employment. Most important was the fact that they spoke the English
language and were familiar with democratic government. Combined with
intelligence, ambition and opportunity, Irish immigrants were able to find
work in a variety of trades and occupations, particularly in big cities and
urban areas.

It is no surprise, therefore, that the largest concentrations of the Irish
in Iowa were found initially in the communities in and around Dubuque,
Davenport and other Mississippi River communities. Irish names abounded
among the miners who worked in the lead mines of Galena, among the
stevedores unloading the riverboats and among saloonkeepers and shop
clerks and other urban trades. For the most part, the Irish were hard workers,
even if some of them were argumentative and given to strong drink.

But the Irish also had some distinct disadvantages. Among the first
immigrants to arrive from Ireland, they had come in the wake of the
Great Famine. They were physically weak, largely illiterate and lacked
even a modicum of job skills. Add to these limitations the fact that the
great majority of these Irish migrants were Catholics, a religion that was

The Irish were the backbone of the railroad construction in Iowa. This image captures workers driving piles on a rail bridge in Sioux City in 1885. *Courtesy of the Sioux City Public Museum.*

suspect to the Anglo-Saxon Protestant majority. Many employers must have thought silently what later appeared in employment advertising: "No Irish Need Apply."

It is illustrative of Irish workers in Iowa to review their status in Dubuque and Sioux City in 1860. Although separated by hundreds of miles, the Irish in these two river cities suffered much the same employment fate. It was as if the *Dubuque Herald* was speaking for the Irish in both cities and perhaps other cities in the state when it noted that nearly all of the Irish citizens of that city were "guilty of the crime of being poor."[80]

It was the 1860 census that told the tale of these two cities. Among the Irish in Dubuque that year were more than three hundred "day laborers"—the largest single occupational category. The next largest group were members of the building trades, followed closely by the miners and transportation workers. Next on the list were shoemakers and tailors and a few saloonkeepers, innkeepers and grocers. There was only one butcher, one druggist and one confectioner. Fewer than two dozen men could be considered professionals. Within this category were eight manufacturers, and

the rest were lawyers, printers and teachers, as well an editor, an architect and an engineer. Another two were justices of the peace.

It is hard to come to any conclusion about the employment outlook for the Irish in Dubuque in the years before the Civil War other than poor at best. For uneducated and impoverished men, there was hard work, and much of that work was day to day. For their wives, sisters and mothers, there was domestic service.

And the same might be said on the other side of the state in Sioux City. To be sure, Dubuque was much larger than Sioux City, but the relative distribution of Irish residents in 1860 was much the same. The majority of Irish-born residents of Sioux City in 1860 were day laborers. Not surprisingly, these workers had little in the way of wealth or property.[81]

The historian William Silag conducted an extensive study of the Irish in Sioux City in the 1860s and came to a dismal conclusion: "While American and German-born Sioux Citians could be found at all levels of the occupational hierarchy before the Civil War," he noted, "Irish immigrants tended to work as menial laborers or construction tradesmen. Men in these jobs were poorly paid to begin with and were particularly susceptible to seasonal layoffs or occasional periods of inactivity throughout the year. Aside from printer William Freney and shoemaker Michael Gaughran, none of the local Irish natives held jobs that might be considered financially rewarding."[82]

As if to make matters worse, there seemed to be little occupational mobility for the Irish-born in Sioux City. Silag pointed to the fact that the "Irish tended to remain within a single job rank through the entire decade." He does note that some of the Irish moved up to take jobs as clerks and skilled tradesmen in the 1860s, but the progress was slow, particularly when compared to other immigrant groups.

The prospects for employment among the Irish-born of Iowa outside the cities was better, particularly in the four decades after 1850. It was something of a boom time for the Hawkeye State, particularly in two distinct and interrelated areas: agriculture and transportation. The expansion of land under cultivation during those decades is well known, and those Irishmen who could afford to purchase a few acres were among the thousands of Iowans who found fulfilment in the fields.

But what of the miserably poor but ambitious Irishman who wanted a better life for his family? More often than not, he took a job laying track on the numerous railroads that were spreading across the state. The "fever," as it was called, began with planning for the Burlington and Missouri Railroad

In addition to work on the railroads, the Iowa Irish also worked in mining and meatpacking, among other occupations. *Courtesy of the Merle Davis Collection of the State Historical Society of Iowa.*

and the Mississippi and Missouri Railroad in February 1853. Not to be outdone, investors chartered the Dubuque and Pacific Railroad later that same year. Other railroads were incorporated during the decade as investors saw new opportunities to reach distant corners of the state.[83]

Once a railroad was chartered, the race was on to find enough men, both skilled and unskilled, to survey routes, acquire land, arrange financing, order steel rails and cut wooden ties. Simultaneous with those tasks, railroad men had to find thousands of workers to grade the land and then lay the ties and rails, one after the other, mile by mile. The demand for the men to do the hard work was substantial, and that was where the Irish filled the need.

Responding to advertisements and circulars that appeared in eastern cities, Irish immigrants flocked to Iowa and other midwestern states to take advantage of steady employment for $1.25 a day, paid in cash. They had little understanding of the perils of this work, but the need for employment was all-consuming. The end result was the close association between the Irish and the construction of the railroads across the country, from the Mississippi River west to Utah.

The work was brutal. Skilled workers surveyed and graded the land, and then the less skilled workers dropped the ties, laid the rails and drove in the

spikes. They worked in all kinds of weather, twelve months a year. On a good day, workers could lay two miles on level ground.

Like all immigrant groups, the Irish worked together in crews and lived where they worked, sleeping in converted boxcars that sat on the rails they had laid the day before. The aggregation of these boxcars and the men who lived in them became known as "Hell on Wheels," an accurate description of the horrendous living conditions at the end of the line. Not surprisingly, gamblers, prostitutes and thieves followed these crews and set themselves to separating the workers from their pay.

Mile after mile, the Irish laid the rails. By the end of the 1850s, they had laid about five hundred miles of track; by 1870, the number of miles exceeded three thousand. By 1890, the rails reached just about every corner of Iowa. Aiding this expansion, the federal government donated over four million acres of public land to the railroads. Together, the railroad companies and the federal government, aided by the sweat and labor of the Irish, changed the nature of transportation in Iowa.

As the tracks were completed in Iowa, Irish workers looked for new opportunities. They had two choices. One was to continue their work for the railroads in different capacities. So in the 1870s, workers with Irish names were commonly employed as engineers, firemen, flagmen and brakemen. Still other Irishmen worked as foremen, station agents, yard masters and even general managers. It was good steady work, and these Irish immigrants purchased homes and lived in communities where they had laid track only a few years prior.

The second employment path was quite traditional. The railroads had received far more land from the federal government than they needed for the rail beds and station operations. In an effort to encourage development of property proximate to the rails, the railroads sold this land to prospective farmers, many of whom had worked on the rails. Not a few Irish farmers in the western counties of Iowa acquired their land from the railroads that had employed them in previous decades.

And that was the path followed by the family of Michael Shelley of Boone County in the 1870s.[84] Michael, his wife, Margaret, and his oldest child, Kate immigrated to Iowa in 1865 and built a homestead on the banks of Honey Creek, a tributary of the Des Moines River. They added three more children to the family over the next twelve years.

Farming was a precarious occupation, even for families of means. The Shelleys were typical of Irish homesteaders: they had a substantial mortgage and needed additional income to pay their bills. In that effort, Michael

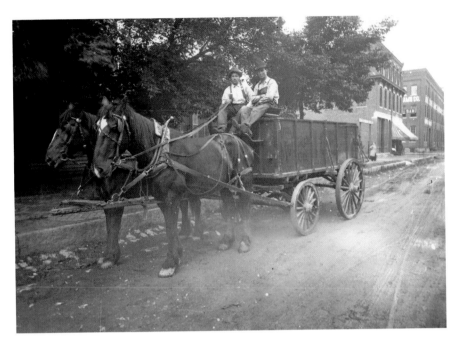

The Iowa Irish also worked in a variety of service trades. This wagon was operated by the Mulgrew Coal and Ice Company in Dubuque. *Courtesy of the Center for Dubuque History.*

worked as a section hand on the Chicago and North Western Railroad. Margaret maintained the farm, and Kate minded her brothers and sisters.

Tragedy struck the family in December 1878 when Michael died suddenly of unexplained causes. Mother and children were now left to fend for themselves, and there is no question that they struggled without the additional income from Michael's railroad work.

Everything changed on the dark night of July 6, 1881. A storm that struck Boone County that night was remarkable, and the rain came down in torrents. Living proximate to the C&N tracks, the Shelleys could hear a locomotive moving slowly toward the bridge at Honey Creek to determine the state of the railbed. The midnight express, a passenger train, was expected soon. If the bridge washed out, the fate of the express was in peril.

Kate saw the light on the utility train—called a pusher—as it moved to the bridge, and then the light was gone. Kate feared that the pusher had dropped into the creek and the bridge was out. Acting with exceptional courage, she struggled to the bridge, determined that it was gone and then

crawled the track until she reached the station at Moingona. Her warning set the agent into action, and the midnight express was saved from ultimate destruction.

Kate Shelley's heroism captivated the nation. Numerous stories appeared in newspapers all over the country for years on end. The family was showered with gifts, including a half barrel of flour and a load of coal. More valuable, the railroad paid off the remaining mortgage on the Shelley homestead.

Kate herself was fêted with gold medals and cash awards from the railroad and the Iowa State Assembly. Thanks to the Woman's Christian Temperance Union, she also received a scholarship to Simpson College in Indianola. Given her father's association with the railroad, she must have been pleased when the members of the local chapter of the Brotherhood of Railroad Trainmen named their lodge in her honor in 1886.

The balance of her life was defined by this heroic act. She worked for a time as a teacher, and her story was a chapter in the third-grade readers used for many years in Iowa's public schools. It was fitting that she was hired as the station agent at Moingona in 1903, and she continued in that job until ill health forced her to resign. She died in January 1912.

Hard work and determination led to success and pride in ownership. This is the Kelly homestead in Benton County about 1900. *Courtesy of Kenneth Donnelly and the Donnelly family.*

Kate Shelley's heroism is largely forgotten these days, but her contributions as a brave Irish girl, the daughter of a railroad man, must have done wonders to underscore the contributions that Irish had made to the construction and care of the state's railroads. That sentiment came through in a poem written by MacKinlay Kantor in 1930. Titled "The Ballad of Kate Shelley," it was published in the *Chicago Daily News* and contains the following stanza: "Across the river bridge a girl came creeping on the ties: The wind wiped out her lantern flame, but still she had her eyes. And still she had her Irish soul and still she had her heart!"[85]

In that brief stanza, Kantor captured the substance of the achievement of the Irish who found work in Iowa. They may have lacked education and resources, but they more than made up for these deficiencies with courage and determination.

George Parker said as much in his book *Pioneer Foundations*, published by the State Historical Society of Iowa in 1940. "Out of them [the Irish] came men, strong, self-reliant, honest and capable," Parker wrote, "the first of a class who could be relied on to construct buildings, public or private, bridges, roads, [and] railroads."[86] Although condescending, Parker did touch on the enormous achievements made by the Irish in building the Hawkeye State in the nineteenth century.

CHAPTER 8
"I AM OF IRELAND"

"I am of Ireland." It was a simple line from a fourteenth-century Irish poem that came to define a national movement for centuries to come. The origin and author of the poem have been lost to history, but that line captured the resolve of a people who had suffered hundreds of years of oppression at the hands of the British government.

That the Irish yearned for independence from Britain was evident in the periodic rebellions that exploded in Ireland in the eighteenth and nineteenth centuries and continued through the Easter Rebellion of 1916 and a bloody civil war that followed. Although these conflicts were suppressed by the British, failure did not lead to resignation. New plots abounded as Ireland faced years of famine in the 1840s and its people spread to the far corners of the earth.

Love of Ireland and a yearning to live free of British oppression—that was the context for the formation of the Fenians in New York City in 1858. Named for warriors who fought for Irish freedom in the twelfth century, the Fenians were committed to advancing the cause of Irish nationalism by any and all means.

That Fenianism spread quickly to Iowa is no surprise, and there were chapters in Dubuque, Clinton and Des Moines by 1866. Although chapters in New York and Boston planned violent activities, the Iowa Fenians confined themselves to rallies and newspaper editorials. The Fenians in Des Moines were particularly active and won the sympathetic support for their cause from the *Iowa State Register*, the leading Republican paper in the capital.[87]

The movement spread across Iowa over the next several years—a measure of the growing number of Irish immigrants in the state. Speakers such as "Doctor Bell" from Dublin and General John O'Neill traveled the state advancing the cause. Fenians in Des Moines and Dubuque also sponsored social functions—Grand Fenian Balls—in the late 1860s.

And yet Fenianism in Iowa did not have deep enough roots to weather adversity, and it gradually declined in the state by 1870. Newspaper editors pointed to an ill-advised invasion of Canada in 1866 as the beginning of the decline. "With England against them on one side and the United States on the other," noted the *Cedar Falls Gazette* on June 15, 1866, "the poor Fenians had to subside….The Army of Ireland, as friends chose to call it, is being disbanded in a sadly demoralized condition."[88]

Although the Irish in Iowa were no longer Fenians, they were still committed to the concept of independence for Ireland. They welcomed and cheered the wife of Jeremiah O'Donovan Rossa, a noted Irish patriot, when she toured the state in 1869, and the same response was accorded to General O'Neill in 1872 when he conducted a lecture tour on the rise and fall of the Fenian cause.[89]

And three years later, the citizens of Dubuque pulled out all the stops to commemorate the centennial of the birth of the "Great Liberator" of Ireland, Daniel O'Connell. Most notable was the parade that followed the speeches. "Every window, balcony and doorway from which a good view of the O'Connell pageant could be obtained," noted the press, "was occupied and the sidewalks were lined with enthusiastic spectators." It was a grand celebration that had drawn delegations from no fewer than thirteen Irish communities across Iowa.[90]

The cause of Irish independence was further advanced in Iowa by two prominent Irish visitors at the end of the 1870s. Michael Davitt, the internationally known Irish nationalist, visited Dubuque in late October 1878. Although he spoke only once, his speech was widely reprinted in the Iowa press. "His remarks had a good effect," noted the *Dubuque Herald*, "and will win sympathy for the land all Irishmen love and all true Americans would love to see free."[91]

The man in the center of the emblem is the great Irish nationalist Robert Emmet. The Fenians were active in Iowa during the 1860s. *Courtesy of the Library of Congress.*

But it was the possibility of a visit from Charles Stewart Parnell, the parliamentary leader of the Irish independence movement, that electrified the Irish of the Hawkeye State. In October 1879, less than a year after the Davitt visit, word reached Iowa that Parnell was planning a tour of the United States to speak in favor of Irish independence and to raise funds to feed the starving people of Ireland. The open question was the specific itinerary for the tour.[92]

Surely he would visit the major cities of the United States in an effort to reach the largest number of Irish Americans. But would he visit rural states such as Iowa, where the number of Irish was small relative to other states? The Irish of Iowa were determined to have Parnell come to their state. They would spare no effort to show that what they lacked in numbers, they more than matched in commitment to the cause.

It was the famine that had gripped Ireland in the late 1870s that so moved Irish hearts in Iowa. It had been only three decades since the poor Irish of County Wexford had themselves escaped famine and settled in Iowa. Just about every Irishman in the state had a personal famine story or knew someone who had embraced emigration. Now it was time to step up and share of their bounty with their less fortunate brothers and sisters.

As he planned his tour, Parnell came to understand that it was starvation more than independence that would move his audiences. Hunger was real and familiar to the American Irish. He crafted a speech titled "An Appeal to the Irish Race" that had three elements. First was to raise money to feed the Irish people who were facing their third consecutive year of famine. Second was to end the English system of absentee landownership, which kept the Irish people in abject poverty even in years of plenty. And finally, it was to overthrow the yoke of the British Empire and win independence for the Irish people.

That Parnell's visit was eagerly anticipated is without question. He began the tour in New York on January 4, 1880, with a capacity speech at Madison Square Garden. Beyond that scheduled speech, the tour was fluid, with Parnell and his colleague John Dillon accepting invitations as received. Like dervishes, they crisscrossed the country, visiting more than forty cities before the end of February.

But would Parnell visit Iowa? There was no question that the Irish in Des Moines and Dubuque would invite the great leader. Before doing so, however, prominent Irishmen in both cities set about to raise money to pay for the visit and assist the cause. These efforts took place in November and December, prior to Parnell's speech in New York.

Many Americans were sympathetic to the crisis in Ireland in the late 1870s and 1880s. This front-page image by Thomas Nast captures the call for help. *Courtesy of the Library of Congress.*

Not everyone in Iowa was on board with Parnell's visit, however. The editors of the *Iowa State Register*, for example, rejected the premise of Parnell's appeal. "The Irish Americans have about paid out the last money for aid to these spasmodic efforts that only end in making matters worse," wrote the editors. They somewhat facetiously added that the solution was to "move the whole population over here where honest industry is sure of winning bread and meat for the pot!"[93]

One unnamed reader joined in with a specific criticism of the tour itself. "Don't give your money to everyone who comes shouting for Ireland," he wrote, "and proposes impracticable measures. These are the kind of Irish politicians who stand around bar-rooms, and amid the froth and foam of beer, shout hurrah for Ireland and want to have a fight. You, my dear people, love Ireland, and so do I; but let not one of us be led by a shillelagh politician."[94]

It was a stinging rebuke. Parnell was no "shillelagh politician," but the reader cast doubt on his fellow Iowans who were raising money for the visit. The insult to the contrary, the planners were not going to be dissuaded from their quest. An Irish Relief Association was formed in Des Moines on January 4, and by the end of the month, three teams of solicitors were raising money among the Irish in the capital and in smaller communities in central Iowa. Funds were designated for famine relief or the general good of the cause.

The Irish of Dubuque were also active during that January. They met regularly during the month and decided to extend an invitation to Parnell and then, once a visit had been secured, conduct a fundraising campaign. A committee was established to meet with Parnell and Dillon when they arrived in Chicago for a scheduled speech on January 20.

Efforts in Des Moines and Dubuque energized the Irish in Sioux City, Davenport, Council Bluffs, Cedar Rapids and other cities. This energy, enhanced by the real possibility of a visit by Parnell, led to contributions of thousands of dollars for Irish relief. But would the great man reward this extraordinary generosity with a visit to the Hawkeye State? The answer would not come until the end of February.

Finally, on February 27, a very tired Charles Stewart Parnell arrived in Dubuque on a train from St. Paul. The crowds along the route had been exceptional, and Parnell and Dillon stopped at every station to say a few words to their acolytes. And the arrival in Dubuque was something of a crescendo, complete with a band, welcoming speeches and even a cannon shot.

That Parnell's arrival in Iowa was highly anticipated is without question, and expectations for his remarks were unrealistically high. But Parnell did not disappoint the crowd, delivering a rather fiery speech that emphasized the mismanagement by absentee landowners that had led to unproductive harvests and starving people. Parnell stressed that Irish land was fertile and could support a population twice the island's current size if managed properly. He concluded his remarks with a passionate appeal for funds for the starving people of Ireland.

At the conclusion of the speech, he was off to the train station for his next engagement: an appearance in Clinton, followed by remarks in Davenport. He spoke on the evening of the twenty-eighth to a diverse crowd that was smaller than anticipated due to inclement weather. Given the hectic nature of the trip, it is not surprising that Parnell delivered the same remarks in Davenport that he had presented in Dubuque. There was no report on the impact of the speech, perhaps an indication of disappointment from the audience.

After a day of rest in Davenport, Parnell and Dillon took the train to Des Moines. The Irish Relief Association was determined to show the great leader how eager the Iowa Irish were to hear him speak. On Parnell's arrival, there were three speeches of welcome, a thirty-two-gun salute, a parade and a reception—all before Parnell had uttered a word. At Moore's Opera House, the largest venue in the city, Parnell was the first to speak. As he had done in Dubuque and Davenport, he attacked the British system of absentee landownership and called on those present to give generously to save lives.

And then he was gone—off on a train to St. Louis and other speaking engagements before sailing back to Ireland on March 13. In an effort to sustain momentum in Iowa, Parnell directed an associate to stay in Des Moines, continue to speak out for the cause and collect donations.

The impact of the brief visit was mixed. Many who heard Parnell speak were enthused, but others thought him too critical of groups other than his own who also were trying to aid the Irish. And Parnell's passionate opposition to English rule seemed to confuse Americans, who were primarily concerned with feeding a starving nation. "Mr. Parnell may be a very well-meaning man," noted the *Iowa State Register* on February 11, "but he has made of his name an offense to many who have heard him."[95]

The *Register* was not alone in this criticism. The editors of the *Sioux City Tribune* were lukewarm about Parnell's visit, and the *Davenport Gazette* spoke volumes by saying almost nothing. Even the *Dubuque Times* was ambivalent about the impact of Parnell on the Iowa Irish on fundraising for Ireland.

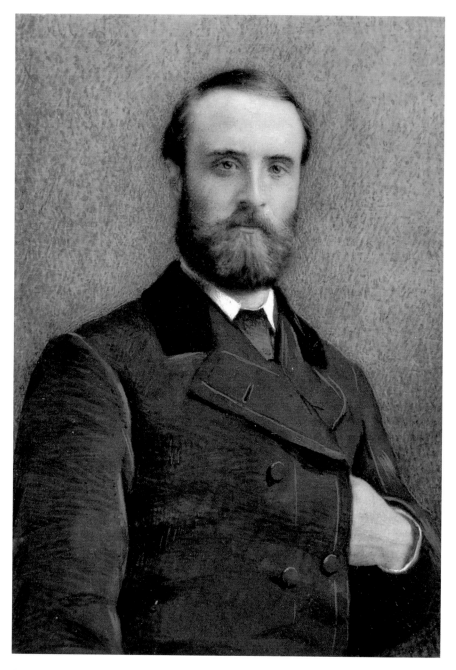

Charles Stewart Parnell was in Iowa for only three days in 1880, but his visit generated an outpouring of funds to feed the Irish people. *Author's collection.*

All could agree that the mission had succeeded because of the cause, not because of its messenger.

The Parnell visit was something of a shooting star. He was in Iowa for a few days, delivered the same speech three times in three different cities and then was gone. It remained for the Irish living in the state to continue the cause, and that they did. In the wake of the Parnell visit, there were new efforts in Des Moines, Sioux City, Dubuque and even small towns to raise money for the Irish Land League. This must have given Parnell a measure of satisfaction since the league was dedicated to the end of the English control of Irish land.

But there was a dark cloud in Iowa in the aftermath of the Parnell visit. Late in 1880, a rumor emerged that a select group of Irish fanatics was planning another attack on Canada. Known as Clan na Gael, these terrorists were loosely affiliated with the Fenians. But who were the men behind this plot, and what was their connection to Iowa? Such a rumor hardly seemed credible.[96]

John D. Macdonald, the prime minister of Canada, thought otherwise. In January 1881, Macdonald received an anonymous letter from Webster City, Iowa, confirming his worst fears. The letter suggested that the plot was real and would be triggered by any effort to stop Parnell in his campaign for Irish independence. Macdonald worried that if Parnell was arrested, "a hundred thousand Fenians will land in Canada in 24 hours." Cautious and concerned, Macdonald requested additional vigilance with border security.[97]

There was no invasion of Canada, but the Iowa Irish continued to stir controversy through anonymous letters that were sent to various publications. One letter, postmarked Clermont, Iowa, and dated January 1882, was typical. "I believe in the dynamite policy," wrote one nationalist, "and am for a fight, believing that by these means alone can Ireland ever gain her independence." It was signed "Voice of an O'Dempsey in Iowa."[98]

Letters such as this one concerned the British government, and officials continued to monitor Irish nationalist activity in Canada over the next several years. Finally, in March 1884, the British government contacted American authorities about information that it had gathered on Fenian activities in Iowa. The specific targets of their concern were two well-known Iowa Irishmen: John Brennan of Sioux City and Michael V. Gannon of Des Moines.

In response to a British request for more information on these two men, the federal government requested that Morris D. O'Connell, a U.S. district attorney from Fort Dodge, conduct an investigation. O'Connell was a well-

No man was more determined to champion the cause of Irish independence than John Brennan of Sioux City. *Courtesy of the Sioux City Public Museum.*

connected member of the Iowa Irish community and traveled widely around the state. He was the man to learn if there was any substance to the rumors about Brennan and Gannon.

O'Connell started with an investigation of Brennan, a man he knew personally. Everyone who O'Connell approached confirmed that Brennan was a man of integrity, not a "warrior or conspirator." O'Connell knew that Brennan was a passionate orator who was closely aligned to the Irish nationalist movement, but there was no evidence that he had any association with the Fenians.

O'Connell did not know Gannon, but he had been told that the suspect lived in Dubuque when, in fact, Gannon lived in Davenport. After a false start, O'Connell focused on the correct Michael V. Gannon, who was a proud and active supporter of Irish nationalist and charitable activities in Iowa and across the nation. As with Brennan, O'Connell found no evidence that Gannon ever ventured beyond oratory. He was neither a conspirator nor a Fenian sympathizer.

O'Connell said as much in his report to the U.S. secretary of state. There was passion for Ireland in Iowa but no Fenian activity. Informed of the government's concern, Governor Burton Sherman supported O'Connell's conclusion—no Fenian activity among the Irish in the state, no massing of arms or drilling of men. O'Connell staunched the apprehension and fear that had concerned both the British and American governments.

Unfortunately, the issue did not die. Brennan and Gannon were no longer suspects, but the British government remained convinced that Fenians were scheming against Canada and the plots were being hatched in Iowa. The Canadians renewed their request for a federal investigation in the spring of 1885, much to the exasperation of State Department officials. Once again, there was no evidence of Fenian activity in Iowa.

The fact that the Irish of Iowa eschewed violence did not lessen their ardor to win justice and freedom for Ireland. Not only did they say farewell to famine in coming to this country, but they also embraced the cause of independence for their homeland in the two decades that followed the Civil War.

And the Irish were joined by many Iowans, regardless of their ethnicity. One did not have to be Irish to embrace the cause of justice. That fact was epitomized in an 1886 letter from William Larrabee, the governor of Iowa, to Patrick Ford, the editor of the *Irish World* in New York. "Home rule for Ireland should find an echo in every truly American heart," Larrabee wrote. "It is, indeed, gratifying to see that this just demand of the Irish people has become a vital issue."[99] In other words, Larrabee was saying for all Iowans: We are of Ireland.

"NO IRISH NEED APPLY"

I t was a simple declaration that resonated across the nation: "No Irish need apply" was a sentence that appeared in a select number of job postings in eastern newspapers. Although rare, the sentence came to summarize the hostility that the Irish faced in their settlement of numerous communities across the United States.

There is no known use of the scurrilous restriction in Iowa, but that did not mean that Iowans were not occasionally hostile toward Catholics in general and the Irish in particular. To be sure, it was an ambivalent anger. Even the most nativist Iowans grudgingly accepted the Irish as contributing to the overall improvement of the state. But there was something about these Catholics that set Iowans on edge.

Nativism, as the movement has been labeled, began in the urban communities along the East Coast of the United State. Before 1820, America had been largely homogeneous—white, Anglo-Saxon and Protestant. Of course, there had always been a number of Jews and Catholics in the country, but their numbers were small and their communities were largely invisible.

Beginning in 1820, however, and continuing for more than a century, multiple waves of immigrants poured into American ports seeking relief from the poverty of their lives in Europe and hoping to embrace the prosperity and opportunities of a new nation. They were impoverished, illiterate and fervent in their loyalty to their ethnic customs and religious faith.

Not surprisingly, there was substantial tension between the natives and the immigrants, and the point of contention was religion. American Protestants

Although many Iowa Irishmen joined the Union army during the Civil War, the response among the Dubuque Irish was mixed. This image depicts an Irish brigade at Catholic Mass. *Courtesy of the Library of Congress.*

were suspicious of the Catholic Church and were concerned that these immigrants were far too loyal to their pope. "I think the Catholic religion has been regarded as the natural enemy of democracy," observed Alexis de Tocqueville when he visited the United States in the 1830s.[100]

Attacks against Catholics took place in many cities in the decades before the Civil War. Hostility was most severe in eastern cities, but it also emerged in the Midwest. There were repeated conflicts in Detroit and Cincinnati and even as far west as St. Louis. In fact, that hostility was codified in the Know-Nothing Party—part political movement but primarily a hate group. The party and the movement reached their zenith in the 1850s, but their legacy continued well into the twentieth century.

Although Iowa was eager for new settlers, the new state was not immune from the nativist movement. Anti-Catholic and anti-Irish hostility migrated to Iowa with its pioneer settlers. "They, like the overwhelming majority of their compatriots, grew up in a society that fostered a tradition of fear and hostility toward the Church of Rome," noted historian Ronald Matthias. "Although many American institutions contributed to the maintenance of this tradition, it received constant nourishment from a large portion of the Protestant clergy in Iowa."[101]

But the roots of this hostility were shallow for several reasons. First, the number of Irish Catholics in the state in the years before the Civil War

was small. Unlike East Coast cities, which were teeming with the Irish, the number in Iowa in the 1850s was only a few thousand, and the majority of these settlers lived in Dubuque. There was no clear and present danger that the Church or its minions would soon be a threat to democracy in the state. Another reason for the muted hostility toward Iowa Catholics was the simple fact that the state was starved for people in general and laborers in particular. The carping of Protestant missionaries to the contrary, Iowa's political and economic classes knew that the state needed workers to till the fields and lay the rails to bring economic prosperity and political power to a state that was not yet ten years old.

Ironically, it was an editor at a nativist newspaper who made the best case for the acceptance of Irish Catholics. "Though immigration is large," wrote the editor of the *Davenport Gazette*, "we would not impede it. We apprehend no bad consequence from its extent. The difficulty is not that we have too many laborers, but too few. How could our canals and railroads have been built without the strong Irish and German immigrants?"[102] In Iowa, economic opportunity trumped any apprehension about ethnic and religious loyalty.

That did not mean that there were no hotheads or political opportunists among the nativists. In Dubuque, for example, a nativist named Osmond Roros fired two shots through a church window during midnight Mass on Christmas Eve 1855. Priests in other communities—Burlington, Fort Madison and Ottumwa—also were attacked. Interestingly, the most activist nativists seemed to reside in the southern tier of Iowa's counties—the counties with the fewest number of Catholic residents.[103]

The nature of nativism in Iowa, therefore, was uneven at best. In fact, the differences among and between nativists and Know-Nothings were most evident

DEMOCRAT AND LEADER——MARCH 8, 1926

M. V. Gannon, Well Known Lawyer and Orator, Dies Here Sunday Afternoon

Possessed "Golden Voice" Which Was Often Used In Espousing Cause of Irish Freedom Before American Public—Practiced Law Both in Davenport and Chicago—Was President of National Land League—Came to America Following Work to Free Prisoners.

Michael V. Gannon of Davenport was a longtime officer of the AOH and a champion of Irish independence. His death was noted in the *Davenport Leader. Courtesy of the Richardson-Sloane Center, Davenport Public Library.*

on the issue of slavery. Nativists in northern Iowa counties were opposed to slavery; those in the southern counties were sympathetic to slavery. The resulting conflict prevented the Know-Nothing Party from becoming a potent political force in the state.

The one issue that united the two factions was temperance. Regardless of their respective views on slavery, nativists generally agreed in the abolition of liquor and were appalled by the growing number of Irish saloons and German taverns. In embracing temperance, the nativists found themselves in line with the prevailing views of the majority of Iowans.[104]

It is important to note that anti-Catholic and anti-Irish hostility in Iowa was stoked by a number of local newspapers. Some papers fanned hostility and suspicion by publishing stories about immigrants and Catholics in states other than Iowa. These papers were compared to "magpies" repeating unsubstantiated charges in an effort to show common cause with other communities.[105]

Such hatred and hostility against the small Catholic community in the state dissipated quickly as the elections of 1856 approached. The emergence of the Republican Party provided a more acceptable alternative for antislavery nativists. The Know-Nothing Party went down to defeat, and the movement seemed to evaporate as quickly as it had emerged.

In the end, Iowans did not respond to a message of fear. One local leader in Davis County put it well in a letter to his fellow citizens. "I am opposed to this secret party," wrote Judge H. Dunlavy, "because I believe its tendency is anti-American, anti-democratic, anti-Christian, causing bloodshed and confusion, destroying confidence among friends and blighting true religion."[106] He appealed to his fellow Protestants to abandon nativism in general and the Know-Nothing Party in particular for the good of Iowa.

It was simple common sense. Iowa had much to lose by rejecting these industrious immigrants. "Every newcomer to Iowa was both a potential and an actual source of wealth for the state," noted Matthias. "But 'strong arms and resolute hearts' were not the exclusive possession of Protestants. Roman Catholics possessed them too."[107] Iowans could see the churches, schools, asylums, hospitals and colleges that dotted the Iowa landscape. It was hard to escape the conclusion that Catholics in general and the Irish in particular were making Iowa a more prosperous, attractive place to live.

But nativism was a deeply rooted prejudice. Although hostility toward Catholicism dissipated in Iowa with the decline of the Know-Nothing Party, it never completely disappeared. In truth, the patriotism of Irish and German Catholics in defense of the Union during the Civil War was

acknowledged in Iowa. And the state continued to welcome wave after wave of Catholic immigrants in the 1870s and 1880s and even championed the cause of independence for Ireland during those years. As late as 1887, there was no reason that Catholics in general and Irish in particular would not be welcome in the Hawkeye State.

Alas, there was a storm on the horizon in the form of a new organization with an ominous name: the American Protective Association (APA). For an organization with such a national name, it is interesting to note that the APA was the result of a local political conflict in Clinton, Iowa.[108]

The conflict arose out of the municipal elections of 1886. The incumbent mayor, Arnold Walliker, represented a progressive reform faction in the community. Largely Protestant, the faction included both Republicans and Democrats, including a close adviser named Henry F. Bowers. Opposing Walliker was a coalition of ethnic voters led by Irish Catholics and their candidate, John W. Pollock.

Although Walliker had been a competent mayor, the largely Catholic community protested that it was being excluded from urban reform. The Catholics were joined in the campaign by the local chapter of the Knights of Labor. An even more potent ally was Father E.J. McLaughlin, the local Catholic pastor, who was outspoken in his support of Pollock.

The election was bitter, and the growing ethnic community voted Pollock into office. Walliker, Bowers and their friends were enraged. Bowers, in

The Sharon family published the *Iowa Catholic Messenger*, which was a voice for the Irish community as well as the Catholic Church in the state. *Courtesy of the* Catholic Messenger.

particular, was determined to seek vengeance against these Irish immigrants and their papist religion. Within a week after the election loss, Bowers had met with several friends and associates to form the APA, with the expressed intention of rooting out ethnic and religious influences in Clinton and around the nation.

The APA was particularly popular in large cities, and by 1894, when the organization reached its zenith, it was said to have more than two million members across the nation. And even in Iowa and other rural states, the APA had a hold. Indeed, the APA leadership claimed more than fifty thousand members in Iowa, a sizable number for that time.

Iowa's Irish Catholics were counseled to remain calm in response to the APA, and they found their voice in the person of Fred Sharon, the editor of the *Iowa Catholic Messenger*. Sharon advised Catholics to "pursue a long heeded course: say nothing, do nothing….Let us have no martyrs here." Sharon's advice was echoed in many Catholic pulpits by priests who advised their parishioners to "ignore those filthy contaminating mercenaries."[109]

That is not to say that all the clergy were that calm. Perhaps the most ardent and articulate critic of the APA was Father Joseph Nugent, the Irish pastor of St. Ambrose Parish in Des Moines, who referred to the association as a "camp of criminal conspirators," thugs who openly violated the fundamental principles of the U.S. Constitution. Nugent found many followers in the capital city, and his remarks were often published in the *Iowa State Register*.[110]

Although APA membership was impressive, the organization had little purpose or policy other than opposition to Catholicism. In fact, fractures within the APA were evident as early as 1890, when Bowers was ousted from the leadership. Although the APA was active and vocal in the presidential election of 1892, the efforts in 1896 to align with the Republican Party were spurned by William McKinley, the GOP nominee and eventual president. Bowers regained control of the APA in 1898, but the organization had lost its influence, and its membership evaporated. The APA died with its founder in 1911.

The short histories of the Know-Nothing Party and the American Protective Association in Iowa are lessons in the nature of intolerance. The Know-Nothings migrated into Iowa from the East but never took hold. The APA was Iowa-born and spread to the rest of the country but had no purpose. Both rose and fell quickly in Iowa and across the nation.

These organizations should not be dismissed as aberrations, however. Separated by a generation, the Know-Nothings and the APA underscore the

THE AMERICAN RIVER GANGES.

This editorial cartoon by Thomas Nast captured the concerns of the members of the American Protective Association regarding the Catholic Church. *Author's collection.*

fact that Iowa was not without anti-Catholic prejudice in general and anti-Irish hostility in particular. Although this prejudice never rose to the level of violence it reached in eastern cities, it persisted like a lingering illness.

"No Irish Need Apply" is a phrase that is now codified in American history—a way of capturing the anger and hostility that accompanied the Irish as they spread west across the country. But that phrase never seemed to appear in Iowa. Although there were Iowans who were concerned about Catholicism and angry at the growing influence of the Irish in their state, the majority of Iowans embraced these newcomers. To be Irish, Catholic and Iowan was not a contradiction in terms. Indeed, by the turn of the twentieth century, they were measures of harmony.

HILLS AND DALES

Hills and dales—the contours of the land in Iowa—are an important element in defining its success in agriculture and in settlement. In fact, one can see that impact in the paintings of Grant Wood, Marvin Cone and other Iowa artists. The land in Iowa is life.

Those hills and dales are also a metaphor for the changes in Irish society in the state between 1900 and 1930. The first decade was a time of general prosperity in Iowa agriculture—something of a golden age—and the Irish benefited from this prosperity. Sod houses and log cabins gave way to board-and-batten farmhouses, and fields grew from 160 acres to 300 or more.

This prosperity did not compromise the concern among the Iowa Irish for the pitiful state of life in Ireland or the lack of progress toward independence from the British Empire. News of famine and political conflict appeared with great regularity in the Iowa press.

The second decade was a time of success, struggle and conflict. Crop prices rose during the first half of the decade but dropped precipitously in the aftermath of World War I.

And the 1920s may have roared in the cities, but they were hard times in agriculture, and all of Iowa suffered as a result. It was also a decade of hate and intolerance with the arrival of the Ku Klux Klan and the presidential candidacy of Governor Al Smith of New York, a devout Catholic and proud Irish American. Although the animosity toward Irish Catholics in Iowa was not violent, there was no question that the Irish felt the lash of intolerance.

We have a glimpse of this turmoil in the memories of Leo R. Ward, who was born in Melrose, Iowa, in 1893. Following his education in Monroe County, Ward joined the Congregation of the Holy Cross in 1914 and traveled the world. Virtually all of his adult life was spent teaching philosophy at the University of Notre Dame, but he never forgot what it was like to be an Irishman in Iowa. His head may have been at Notre Dame, but his heart remained in Melrose.[111]

Ward recorded his memories of Irish life in Iowa in a 1941 book titled *Holding Up the Hills* and in several subsequent essays published in the 1970s. In these works, Ward offered an intimate portrait of Irish life in Iowa in the early years of the twentieth century.[112]

He was the son of Irish pioneers who had come to Monroe County in the 1850s. His father was from County Cavan and his mother from County Mayo. Ward recalled his parents telling him that they shared a common purpose in their journey to Iowa: to escape the ravages of famine in their homeland. The Wards were one family among many who settled in three small Irish communities in the county. Melrose, Georgetown and Tyrone were a triad of Irish culture in southeast Iowa, and Leo Ward was their bard.

The Iowa Irish had achieved a measure of prosperity by 1900. Here are Irish American residents of Garryowen at a picnic in 1908. *Courtesy of the Archives Office–Archdiocese of Dubuque.*

It is hard to underestimate the compelling determination of these families to settle and stay in Iowa. "With our people," wrote Ward, "for a long time it had to be either one of two destinies, going on west or staying here at home. Any third place would seem foreign. The east never did speak to us, and after ten or twelve years in our nest among the southern Iowa hills, few of our transplants felt so displaced as to make even a dream journey to Ireland."[113]

That did not mean that the Irish of Iowa in general or the Melrose Irish in particular gave up memories of their homeland. "When people spoke once in a while of how things were 't'home,'" Ward added, "the reference was not to Boston or Canada, but to Ireland."[114] These memories were, of course, fraught with both sorrow and longing. "The anti [British] feeling was stronger than the memory of the real Ireland." Ward further recalled. "The former extended for generations whereas the latter faded and faded."[115]

By the turn of the twentieth century, succeeding generations were fiercely Irish in their identity and vocal in their support for Irish aid and independence, but they had only scant knowledge of the famine and suffering that had sent their grandparents from Ireland to the United States and on to Iowa in the first place.

Life for Ward and the rural Irish in Iowa was idyllic during the first decade of the twentieth century. With his brothers, sisters, cousins and extended family and friends, young Leo was sent off to school for what he remembered as "our six to eighth month hassle." Most of the other students were well known to Leo—children from other area Irish families. There were, of course, a few outsiders—non-Irish children. Ward recalled them as "displaced persons; we were supposed to keep mum about our ethnic superiority."[116]

Ward progressed through the public schools of Monroe County with little difficulty and by the age of eighteen in 1910 had begun a four-year sojourn as a teacher in one of the several one-room country schools. He taught basic literacy and doled out discipline to Irish American children who were well known to him. "The school ran itself," he recalled. "The state ran itself; the church, a long way from Rome, had that habit too."[117] Irish life in Iowa was local and intimate for Leo Ward, but that was about to change.

In 1914, at the age of twenty-one, Ward entered the Congregation of the Holy Cross and journeyed east to South Bend, Indiana. For the next thirteen years, he studied for the priesthood. Two years later, in 1929, he received his doctorate in philosophy from the Catholic University of America and began a three-decade tenure as a professor at Notre Dame. He never again lived in Iowa, but Ward never forgot his roots. "Although Ward wrote about myriad

Irish American women championed the cause of Irish independence. Here they protest the British occupation of Ireland in 1918. *Courtesy of the Library of Congress.*

subjects," noted historian Ryan Dye, "he clearly saw rural Iowa and Ireland as his two key influences."[118]

Add to those influences a deep-seated belief in the constant presence of God in all things and a haughty sense of superiority in being Irish. "We took God to be everywhere," Ward wrote, "in the fields and lots and houses and wakes." He further noted that the Irish never lost their faith and would pray the rosary to ask the Blessed Mother to intercede with her Son to send rain to Monroe County.[119]

The sense of superiority was something of a character flaw. Ward remembered that the non-Irish among them were referred to as "Hoosiers." "Hoosiers were an inferior people," he remembered. "We knew that. But in what sense? Did we think ourselves better than they were, better men, women, and children?"[120]

Ward was certain that this superiority was not a matter of salvation but rather a sense of the non-Irish being inferior in terms of social status, education and financial resources. That was what it meant to be an Irish Iowan in the first two decades of the twentieth century.

Even though Irish life in Iowa was generally peaceful during those years, thoughts of "home"—that is, Ireland—were never far from mind. Iowa's

newspapers regularly reported on the persistent famine and chronic political turmoil that defined the lives of the Irish people for over a century. That the Irish of Iowa were grateful for their good fortune in their life in the Hawkeye State is without question. It is also true that many Irish Iowans experienced concern over the state of affairs in their homeland.

That anger and concern was certainly evident in the sermons and lectures of Monsignor Michael Flavin, the pastor of St. Ambrose Parish in Des Moines. Flavin was well known within the Irish community in Iowa as a passionate spokesman for the Irish cause. Throughout the first decade of the twentieth century, Flavin spoke out on the English atrocities in Ireland and the resulting diaspora of the Irish people. If such policies continued, Flavin warned, Ireland would be a wasteland and the Irish people would be no more.[121]

Flavin was remorseless in his attacks on the English overlords. "The English have attacked our institutions, made fun of our religion, scorned our schools and placed a ban on our school teachers," Flavin intoned. "They gained the country by robbery and rape. It will be restored by recognition by the civilized world."[122] Flavin became an Iowa spokesman for Irish peace through political justice.

Although many Irish Iowans endorsed Flavin's call for an independent Ireland, there was disagreement over the path to achieve that goal. Some called for the Irish to support a new paramilitary organization known by its Irish name, Sinn Fein, translated as "Ourselves." Others, such as Fred Sharon, the editor of the *Iowa Catholic Messenger*, were vocal in criticizing the use of violence. Like many Irish Iowans, Sharon supported the steady pressure being brought on Parliament by Irish leaders such as John Redmond.[123]

Sharon remained adamant that violence was no tactic and urged the Irish to abstain from protest during the World War I years from 1914 to 1918. He was quite vocal in criticizing the Irish patriots who mounted a rising at Eastertime in 1916 and focused his anger on the Irish Americans who encouraged such violence. Sharon further applauded the American government for investigating the movement.[124]

In the aftermath of the war, as the Allies divided the world into new independent nations at the Paris Peace Conference, there were renewed efforts to win home rule for Ireland. But the British were not yet willing to loosen their grip, and the "troubles," as they were called, persisted into the 1920s.

But Irish Iowans such as Michael Gannon and Michael Flavin would not give up even if they were dispirited by the chaos. "Nobody can foresee what a week or a month or a year may bring forth," concluded Flavin following a

The Daly family of Johnson County takes a drive in the summer of 1920. Prosperity had come to the Iowa farm economy in the 1910s. *Courtesy of Dan and Beth Daly.*

tour of Ireland in 1920. "The whole situation is disgusting and the outlook not hopeful."[125] It would be another year of violence and civil war before the Irish would win limited home rule.

A new decade meant new challenges for Irish Iowa. Low crop prices in the aftermath of World War I were a source of persistent worry for Irish farm families like the Wards of Melrose. In urban areas such as Dubuque and Davenport, Irish American law enforcement officials were in conflict with Irish American bootleggers in a constant effort to enforce the prohibition of the distillation and sale of alcohol.

Yet another source of tension in the nation was the reemergence of the Ku Klux Klan and a correlate rise of anti-immigrant, anti-Catholic hostility. Iowa, of course, was not immune. In fact, the surprising appeal of the American Protective Association in the 1890s put Irish Iowans on notice that their Protestant neighbors might well harbor ill feeling toward them.

But the power and appeal of the Klan in Iowa in the 1920s was limited and varied substantially from county to county. Chapters known as "klaverns" appeared in Des Moines, Jefferson and other Iowa communities in 1922 and 1923. By 1926, the Klan in Iowa had reached its zenith with an estimated forty thousand members in over one hundred klaverns.

Although its growth was impressive, its roots were shallow. Within two years, when an Irish Catholic was running for president, the Klan had all but disappeared in Iowa.

It was almost as if the Klan in Iowa was a form of civic entertainment. Those who have researched this secret society agree that the common theme of Klan activities in the state was theatrics—dressing up in white robes, carrying lighted torches and burning crosses at evening rallies. Although some of the rhetoric could be considered intimidating, there was no Klan violence in Iowa.

The one Klan event in Iowa that might be considered confrontational took place in West Branch in 1925 as the family of Maurice Cahill, a local Irish Catholic farmer, was moving to a new home two miles southwest of town. As Maurice drove his wagon full of his belongings through town, he was confronted by bonfires and surrounded by masked men in Klan robes. No words were spoken, and no action was taken to stop the Cahill wagon. Maurice and his family moved on without further incident.[126]

Was this an effort to intimidate the Irish in general or the Cahill family in particular? It is impossible to prove either way. Many residents remember the story, and it has persisted in town lore ever since. That having been accepted, the Cahill family prospered on their new farm for generations with little concern for their safety. The Cahills would not be moved.

It is true that the Klan was responsible for a persistent anti-Catholicism that was common at rallies and in the scurrilous pamphlets that were distributed across the state. The anti-Catholicism was fueled by a well-known defrocked priest with grievances against the Church, but his vitriol did not precipitate any violence—no personal attacks or church burnings in Iowa.

One might have expected an increase in Klan activity in 1928 when the Democratic Party nominated an Irish Catholic from New York as its candidate for president of the United States. Although Smith had been a successful governor of a large state, he represented values that were controversial in Iowa. Of particular concern was that Smith had little understanding of the challenges faced by agriculture and that he advocated the repeal of the constitutional amendment prohibiting the distillation, sale and consumption of alcoholic beverages.[127]

Smith had ardent supporters in Iowa, of course, particularly among the urban Irish residents of Dubuque, Waterloo, Des Moines and other cities. Indeed, the delegates who represented Iowa at the Democratic conventions in 1924 and again in 1928 agreed with Smith on Prohibition repeal and

admired the governor for his forthright stand. County conventions in Iowa were dominated by Irish Americans such as John Sullivan of Waterloo.

There also was concern about Smith's religion. Catholicism had been a part of Iowa life since the 1830s, yet it remained a minority religion. Dubuque County was predominantly Catholic, and there were substantial Catholic communities in many Iowa cities and counties. Outside the cities, however, the number of Catholics was small, and Iowa was a distinctly Protestant state.

In fact, Iowa was Protestant by a factor of ten to one, and as with other states with large Protestant populations, there was a concern that the pope might have an undue influence on Smith were he elected president. Indeed, there were some ministers who argued that Catholics could not be loyal to their religion and also serve as president.

As if these issues were not enough to daunt his campaign, Smith faced a Republican candidate who had been born in Iowa. Herbert Hoover, the fabled humanitarian and secretary of commerce, had been born in West Branch and was something of a favorite son.

It is not a surprise, therefore, that Smith did not campaign in Iowa. He did traverse the state by train on his way from Chicago to Omaha, and he did stop to deliver remarks in several Iowa towns, but that was it. He delivered a major speech on agriculture when he stopped in Omaha. The speech was addressed to "fellow citizens of Nebraska and adjoining states," and it was broadcast by radio across Iowa.

But Smith's image as a tool of a corrupt urban political machine and a dogmatic foreign religion were too much for his campaign to be successful in Iowa. He was slammed in the Iowa press and caricatured by editorial cartoonists as a corrupt drunk who was unfit for the presidency. And those Iowans who challenged those false charges were slammed as being "too damn dumb" to understand the issues.

The Irish in Iowa were willing to stand up for Smith and went so far as to say the Democrats would do more for farmers than the Republicans. Newspapers in Spencer and Emmetsburg were among the most vocal in making Smith's case. This is not to say that Iowa's Catholics in general or the Irish in particular had high expectations for Smith in Iowa. They were proud of Smith but realistic about his chances.

When Election Day came that November, the results in Iowa were as expected. Hoover won 62 percent of the vote and carried ninety-three of the state's ninety-nine counties. As expected, Smith prevailed in Dubuque County and also won a cluster of four contiguous counties in the center of

The Ku Klux Klan organized rallies in Dubuque County in the 1920s. The Klan used the "burning cross," here illuminated with electric lights, to rally its followers. *Courtesy of the Center for Dubuque History.*

the state and Plymouth County in the west. The one bit of good news for the Democrats was the fact that Smith had done better than their candidates in the previous two presidential elections.

The election of 1928 brought a close to a generation of change for the Irish of Iowa. They prospered in both number and in wealth. They approved of the shift toward independence for their beloved homeland even if they condemned the persistent violence. With other farmers in the state, they struggled with a farm crisis that would not end, but they also were proud that one of their own was chosen to run as a candidate for president of the United States. It was a generation of hills and dales.

CHAPTER 11

DEPRESSION AND WAR

The election of 1928 was something of a high point for the Irish in Iowa. There was no denying the disappointment of Al Smith's loss of the presidency to Herbert Hoover. And yet the Irish were likely pleased that they were a people to be reckoned with as the state faced a new decade.

One small indication of the place of the Irish in Iowa was a simple ceremony held in West Branch on August 10, 1929. As a gesture of appreciation and acknowledgement for the new president, the Daughters of the American Revolution dedicated a plaque in his honor. Prominent among speakers was the Reverend Edward J. Flanagan, the founder of Boys Town in Nebraska.[128]

It is likely that the new president had asked Flanagan to speak for strategic reasons. Certainly Hoover wanted to underscore the fact that even orphans like those from Boys Town could become president of the United States. And in giving a prominent part in the ceremony to Father Flanagan, Hoover also acknowledged both the Catholic Church and the Irish American people.

Although many Irish Iowans had supported Smith, they also were proud that a native son had been elected president. In fact, most Americans had high hopes for the Hoover presidency. He had fed Europe during and after World War I. He had noticeably improved the quality of American life during almost eight years as secretary of commerce. In fact, Hoover's accomplishments caused Democrats to ask somewhat facetiously if the man known as the "Great Humanitarian" was human.

But the great promise of the Hoover administration came crashing down in October 1929. The collapse of the stock market did not cause the precipitous decline in the American economy, but it was a harbinger of hard times to come. In Iowa and across the nation, the American people would suffer through a decade of unprecedented poverty and devastation. In fact, the American economy did not fully recover until world war led to full employment.

As was the case with other farm states, Iowa had already suffered through drought and low crop prices during the 1920s. By the time the stock market collapsed in 1929, Iowa farmers—the Irish included—were at a low point in their lives. Many farmers had little more to their names than the land they farmed with frustrating results.

So the challenge for Iowa farmers was to learn to cope with subsistence on a daily basis. Some farmers could not bear the burden, and suicide became common in Iowa and elsewhere. Other farmers leaned on family, friends and faith for moral and financial support. Communities—particularly those with common values and ethnic traditions—learned to cope with hardship during the 1930s.

Happy days came back with the end of Prohibition. Here Harold Donnelly serves a beer to a customer in about 1935. Donnelly's would become known for serving green beer on St. Patrick's Day. *Courtesy of Ken Donnelly and the Donnelly family.*

That was the circumstance for the Irish of Melrose, a community in Monroe County. That we know how these farmers survived the Great Depression is thanks to Leo Ward. Father Ward regularly returned to his hometown to visit with friends and family and take the pulse of their lives. As a result of these visits, Ward became the voice of the Irish in rural Iowa.

Ward wrote two books about the Irish that inform us of their struggles. *Holding Up the Hills* was published in 1941 and is considered something of a minor classic in American Catholic literature. *Concerning Mary Ann* appeared in 1950 as something of a sequel. Both books told the story of multiple Irish families in the communities of Melrose, Georgetown and Tyrone from the 1850s up through the 1930s.

In *Holding Up the Hills*, Ward captured the contours of Irish life in Iowa during the 1930s. The tone and style of the book make it something of a modern parable. He begins the book, for example, talking about "The Granger," a hardscrabble farmer who quietly survived hard times by never forgetting his roots. "His family was first and last as the center of his life," wrote Ward, "and without fuss or complexity, he was steadily loyal to home and people."[129]

Ward also articulated the nature of The Granger's religious faith—his Catholicism. "Religion had to be simple for him," wrote Ward, "as simple as eating a meal or plowing a field....He went quietly to church on Sundays and holy days, received [communion]—as was then the custom—a few times a year, especially for his departed relatives, and we may be sure prayed for rain and for fair weather."

Ward also profiled Mary Ann Cawley, a neighbor of The Granger and the mother of thirteen children. Ward was eloquent in discussing the burdens of daily life on Irish women such as Cawley. Although their husbands were good men, it was not uncommon for Irish housewives to shoulder the primary responsibility for the welfare of all in their households. "Her hands have always been full," noted Ward in describing Mary Ann.[130]

Ward was prosaic in summing up the lives of Irish women in Iowa during the Depression—"hope and prayer and endless labor," wrote Ward. "She expected no favors and got very few," he added. But Ward understood that these women were strong in the face of personal adversity, drought and crop failure. "She has remained self-possessed and unconquerable," he wrote. "In a real sense, she will never wear out; she can't."[131]

In praising the strength of Irish farm wives, Ward did not mean to diminish their husbands. These were men who had faced true adversity and lived to tell the tale. "He came to this land, like so many others, with his

hands empty," noted Ward with a measure of admiration. He went on to list all the challenges that the Irish in Iowa had faced collectively—breaking the plains, building the railroads, raising families, suffering the loss of loved ones and now facing the devastation of the Great Depression. "One way or another he has gone through a whole series of hard times," concluded Ward, "but today he is as always a man of ready heart, and his knees have never wobbled."[132]

In hard times, Ward added, the power of place was not to be minimized. "Home was sacred and quite compact," he wrote movingly. "It was almost everything to everybody. We did not have to be asked to love home—we did love it; nor to stay at home—we had no longing for distant or strange places."[133] These were the Irish of Iowa—content with who they were and where they were.

Catholicism offered hope in hard times. Here is Father Walsh with the First Communion class of 1936 at St. Joseph's parish in West Liberty, Iowa. *Courtesy of Helen Tucker Sorenson.*

What of the Irish who lived and worked in Iowa's cities? Without question, there was a sizable number of these families in all the communities along the Mississippi and Missouri Rivers and in Iowa City, Des Moines and Waterloo, where there was work for a man with quick hands and a strong back. Even a casual review of city directories for the 1920s and 1930s shows that many Irish Iowans worked in a broad cross-section of trades. The one challenge they all faced was poverty. The hard times of the 1930s spared few professions, and the Irish in Iowa's cities were among the suffering.

There were exceptions, of course. Irishmen such as Tom Sullivan of Waterloo were fortunate to be employed on the railroads, and their services were not affected by the fluctuations in crop prices or the demand for agricultural equipment or processed meats. Employment in those sectors dropped quickly, but the trains continued to run even if their volume of freight had diminished.[134]

Sullivan was indeed a fortunate man. He was born on July 20, 1883, on a farm near Harpers Ferry in Allamakee County. He was one of nine children in the family, and as the firstborn son, it might have been expected that he would stay and help his father with the farm. But at age sixteen, Tom struck out on his own, wandering west to Montana before returning to Iowa in 1910. He chose to settle in Waterloo, where he found work as a yardman on the Illinois Central Railroad.

By 1930, Tom had married Alleta Abel, fathered five sons and a daughter and earned a promotion to brakeman. He was earning close to $100 a week at a time when his neighbors felt lucky to be making $20 a week. And as a union man, Tom had protection against layoffs. There is little in Tom Sullivan's story that could considered typical of the working class in Iowa's cities in the 1930s.

The same might be said of the Sullivan children. The oldest was George, born in 1914, followed by Frank in 1916, Genevieve in 1917, Joe in 1918 and Matt in 1919. Then there was a break until the arrival of Al in 1922 and finally, in 1931, Kathleen, who later died in infancy. The Sullivan household also included Aletta's mother, May, a widow. By 1932, the extended Sullivan family had settled in at 98 Adams Street, a short walk from the railyard where Tom worked.

Life for the Sullivans was conventionally urban Irish. All of the children received a basic education at St. Mary's Parochial School and at local public schools. Alas, none of the boys was much of a student, and only Gen graduated from high school. The children identified as Irish and Catholic and attended Mass in their youth but received the sacraments fitfully. As

One bright moment for the Iowa Irish was the 1937 state basketball championship won by the Shamrocks of tiny Melrose High School. The Shamrocks were the first undefeated championship team in state history. *Courtesy of John P. O'Brien.*

was the case in some Irish families, there was little encouragement for the children to make something of their lives.

The Sullivan boys quickly gained reputations as "pluggers." They worked part-time jobs for pocket money but lived at home even as young adults and depended on their father's income for living expenses. And with few prospects, the Sullivan boys were known to be fighters. "Life was hard, a real struggle," remembered one neighbor. "You had to fight to survive."[135]

Even though Tom's salary was sufficient to cover family expenses and he had job security, the Sullivans were not immune from the devastation of the Great Depression. The boys came of age in the 1930s, but their fitful efforts to find work were unsuccessful. With their father's help, George and Frank were hired on as yardmen at the railyard, but they both quit when they found the work too hard.

Without jobs, the boys were well known as regulars at several taverns and at Carter's Pool Hall, a few blocks from home. On the social side, the boys also frequented dance halls such as the Farm Roof and the Electric Park

Ballroom. Although all the boys were social, none of them showed much interest in dating or marriage.

The boys also enjoyed the picture shows, as they were called, and the offerings in Waterloo included action films such as *Devil Dogs of the Air* and *Shipmates Forever*, which may have been the inspiration for George and Frank when they enlisted in the U.S. Navy in 1937. Without prospects or focus in Waterloo, the two oldest Sullivans saw the navy as a way to experience the adventure they had seen at the movies.[136]

It was a fateful decision that was enhanced by the permission granted by the navy for the brothers to serve together during their four-year hitch. It was a common practice for the navy to allow relatives to serve together during peacetime, and this may have been the tipping point for two brothers who had vowed to "stick together."

Together, George and Frank were inducted in Des Moines and sent off to San Diego for ninety days of training. After they completed their training as seamen apprentices, they were assigned to the USS *Hovey*, an aging destroyer from World War I. Although the work was hard, the boys did get to see the Pacific, as the *Hovey* sailed south to Mexico and Central America and west to Hawaii.

And the navy made men of these two Sullivans. Although both boys were disciplined for drunkenness, they also achieved a measure of success and became petty officers in due time. This achievement gave both George and Frank a measure of pride, and they returned to Waterloo in late 1939 to local acclaim. Their mother also was proud and became one of the founders of the Navy Mothers of Waterloo, a civilian support organization.

Life for the Sullivan family changed forever on December 7, 1941. As was the case for all Americans, the Sullivans learned of the Japanese attack on Pearl Harbor and that the country was now at war. Most Americans had no knowledge of Pearl Harbor, but for George and Frank, it was a second home. They had been based there for a time during their service.

So it was no surprise that George and Frank took the attack as a personal affront. And adding insult to this injury was the news that a good friend was among the casualties. In response, all five Sullivan brothers enlisted in the navy on January 3, 1942. Their only request at enlistment was that they serve together. Although it was against policy to allow siblings to serve together during wartime, the navy made an exception for the Sullivans, and they were all assigned to the *Juneau*, a lightly armed cruiser.

The fate of the five Sullivan brothers was determined on November 13, 1942, during the Battle of Guadalcanal, when two Japanese torpedoes hit

the ship near the ammunition magazines. The *Juneau* exploded and sank almost immediately. In assessing the damage, the senior on-site commander assumed that no one could have survived the blast and did not order a rescue. Although some men survived, all five of the Sullivan brothers were lost.

The news finally reached the Sullivan family on January 11, 1943. As Tom Sullivan was preparing to go to work, three men in navy uniforms knocked on the door. Tom had heard rumors of the battle and knew that the *Juneau* had been in the action. When he saw the navy men on the porch, he knew why they were there. "Which one?" Tom asked. The response was startling: "I'm sorry. All five."[137]

The news that day changed the future for the Sullivan family forever. Such an enormous sacrifice epitomized the war effort, and the Sullivan family was inundated with expressions of sympathy from the president of the United States as well as ordinary American citizens. "They did their part" became the motto of the Sullivan contribution to the war effort.

And the physical symbol of this contribution came in the form of a new destroyer named *The Sullivans*. The ship was commissioned in San Francisco

The tragic loss of all five Sullivan brothers became a rallying cry during World War II. The story of the "Fighting Sullivans" was made into a Hollywood film in 1944. *Author's collection.*

on April 4. Both Tom and Alleta were present for the event and found solace in the praise heaped on their boys. Both of them participated willingly as a form of therapy. "I lost my own five," Alleta told a reporter, "but there are millions of other boys I feel belong to me. They're my family now."[138]

And the War Department took advantage of this sentiment. Over the next two months, Tom and Alleta were sent on a whirlwind tour of defense plants to rally workers to produce more and better armaments. By the middle of June, family members had attended over 230 rallies and spoken to more than one million workers.

The notoriety surrounding the Sullivan sacrifice was further enhanced by the production of a motion picture about their lives. *The Sullivans*—later known as *The Fighting Sullivans*—was a B-grade picture that concentrated on the lives of the boys before their navy service. It premiered in February 1944 and received respectable reviews.

And then it was over. As the war dragged on into 1945, a certain measure of normality returned to the Sullivan home on Adams Street. And yet Iowans in general, and the people of Waterloo in particular, never forgot the Sullivan brothers. Streets and buildings in that community still bear their name. "We stick together"—a phrase used frequently by the boys in both peace and war—might well be ascribed to Americans in general and Iowans in particular.

The years from 1930 to 1945 were the very definition of sacrifice for the American people. After a decade of economic depression, the country faced five years of world war. In many ways, these sacrifices were reflected in the lives of the Irish farm families of Melrose and the Sullivan family of Waterloo.

It is important to note, however, that the experiences of these two communities were only two examples of the contours of Irish life in Iowa during the middle years of the twentieth century. The stories of other Irish people in other Iowa communities are also important but have yet to be written.

FOREVER IRISH

The generations that followed World War II were years of prosperity and turmoil for the American people. A decade of full employment and Cold War was followed by a civil rights revolution and an unpopular conflict in Southeast Asia.

The nation witnessed the election of the first Irish Catholic president, the first resignation of a president, the election of a former movie star as president and the election of the first African American president—all this in little more than sixty years.

The world war also had a leveling impact on social and religious values. Organized religions, for example, struggled to maintain their membership as the nation became more concerned about the here and now than about the hereafter. Sex, drugs and rock-and-roll became common elements of American culture.

It is also true that some aspects of American society did not change amid all the turmoil. That certainly could be said of ethnic identity in general and Irish pride in particular. Although the Irish throughout the United States reached extraordinary levels of social, educational and economic achievement, they never forgot their roots. No matter how many generations had passed since their ancestors had left the old country, they were forever Irish.

That pride was most commonly expressed each March 17, St. Patrick's Day, in the nation's largest cities. On that day, the Irish assembled for parades in honor of all they had achieved since coming to America. Following the

Harold Donnelly (*center*) was the proprietor of one of the most popular Irish taverns in the state for nearly five decades. After selling Donnelly's in Iowa City, he served as a Johnson County supervisor. *Courtesy of Kenneth Donnelly and the Donnelly family.*

parades were speeches, toasts and traditional Irish music. In fact, the robust nature of these celebrations encouraged millions of Americans to adopt St. Patrick's Day as a semi-official national holiday. It seemed that everyone, regardless of ethnicity, was wearing buttons that read "Kiss Me, I'm Irish."[139]

The Irish of Iowa were enthusiastic participants in the celebrations. In fact, there is evidence of Iowans celebrating St. Patrick's Day as far back as the 1860s. And these events continued year after year, decade after decade for the next century. For the most part, these events consisted of speeches and concerts in honor of the day. But in recent years, the Irish of Iowa joined in the marching, and St. Patrick's Day parades have been common in many Iowa communities.

Why did Iowa embrace the day as its own? That was the question asked and answered by the editors of the *Mason City Globe Gazette* in an editorial in 1934, but it remains a valuable observation to the present day. Simply stated, the editors saw St. Patrick as a symbol all Americans held dear.

"America loves men like Washington and Lincoln, and St. Patrick in his way was a man of that type," explained the editors. "America likes the Irish because America itself is so much Irish and because the Irish have given us so many of their virtues and so many of their faults."[140] It was a clear and succinct explanation of the pervasive popularity of St. Patrick and his day.

Perhaps the best measure of the persistent appeal of sustaining Irish identity came through in the popular press. Year after year, daily and weekly newspapers across the state took notice of all things Irish during the third week of March. For the most part, these were brief notices of a parade, a lecture or a dance. But as an accumulation, they reminded all Iowans of the pride that Irish Iowa had in its heritage.

One high point for these stories came in the 1960s, when two of Iowa's most popular newspaper columnists celebrated the friendly sons and daughters of St. Patrick. It was on St. Patrick's Day in 1964 that a popular agricultural journalist named Herb Plambeck published an homage that he titled "A Great Day for the Irish—In Every County of the State of Iowa." It was in this column that Plambeck saluted all the contributions that the Irish had made and continued to make to Iowa's agricultural bounty.[141]

Four years later, the veteran journalist George Mills wrote a cover story with a salient title in the form of a question. "What Would Iowa Be without the Irish?" Mills asked. After reviewing the many contributions that the Irish had made to the contours of Iowa's historical landscape, Mills underscored what had become evident to the entire state. "St. Patrick's Day no longer is the exclusive property of the Irish," Mills wrote. "A lot of

Dan Daly of Iowa City has become the embodiment of the patron saint of Ireland and a popular participant in the annual St. Patrick's Day Parade in Cedar Rapids. *Courtesy of Dan and Beth Daly.*

non-Irish celebrate also. Time was when only the Irish wore the traditional Irish green on this day. Nowadays you see Larsens, Vander Zyls, Schmidts, and Jones wearing green ties, green dresses and maybe sprigs of shamrocks in honor of St. Patrick."[142]

The late 1960s and 1970s brought violence to Ireland in the form of a widespread conflict known as "The Troubles." Generations of mistreatment of Catholics in Northern Ireland at the hands of an Ulster Protestant majority led to protests for civil rights and terrorist attacks by the IRA (Irish Republican Army). The conflict between the two factions would last until the end of the twentieth century.

Iowa commentators could not help but take notice of the conflict. One prominent authority in the state was William Cotter Murray, an Irish-born professor of English at the University of Iowa. Murray was well known for his poignant novels of Ireland and his passion for social justice. In a column titled "Wearing Red," Murray reviewed how Ireland found itself in such a sad state of affairs. Noting that more bloodshed was likely in the near term, Murray nevertheless held out hope. "The next generation— North and South," he concluded, "can grow up free and in peace, not in

a land of terror and fear and injustice. And we can wear the green again, without the red."[143]

Murray's hope was shared by thousands of Iowans who had read about "The Troubles" with dismay. But what did the Irish of Iowa know about their ancestral land? Some critics were concerned that too many Iowans were Irish for only a few hours each year when they toasted St. Patrick or marched in a parade.

That state of affairs might well change. "With renewed violence in Northern Ireland," wrote Maureen McCoy in a letter to the *Des Moines Register*, "people here are reminded that Irishness is not all greenery and beer. And—country and western music on St. Patrick's Day? That doesn't say much for the validity of these 'Irish' opinions."[144]

It was a fair criticism. Was there evidence that Iowa's Irish identity was anything other than swilling a few beers on St. Patrick's Day? It seemed as if the editors at the *Register* wanted to know, and over the next few years, the paper featured stories about Irish Iowans who were preserving cultural traditions.

Among the most unusual Iowans to cherish his Irish identity was one Patrick Morrissey, who was featured in Tom Carney's "Over the Fence" column in the *Register*. Born blind in 1902, Morrissey became a teacher, a

Dedicated in 1996, the library at St. Ambrose University has become an important center for Irish studies in Iowa. *Courtesy of the St. Ambrose University Archives.*

piano tuner and a librarian. And even though he was a third-generation American, Morrissey never compromised his Irish heritage. "It takes from two to four generations for that to get out of you," Morrissey noted, quoting a friend. That certainly was the case for Morrissey, who devoted himself to preserving the use of the Irish language in Iowa.[145]

Two more guardians of the Irish tradition in the state were Bill and Grace Eckley, professors of English at Drake University in Des Moines. The Eckleys were passionate about preserving the "lilting melodies and rich folklore of the Emerald Isle into a presentation about Irish folk songs."[146]

The Eckleys were not unique in this effort in Iowa. Other traditional music groups could be found in Iowa City and Dubuque, among other communities in the state. All of these groups saw their mission as cultural preservation, historical education and, of course, entertainment. "The Irish songs are great," noted Bill Eckley. "They're fun to sing." And these songs became a way of keeping Irish heritage alive in Iowa after more than a century of settlement.

Shoulder to shoulder with the Eckleys and other Irish musicians were the organizers such as one Tom Lenihan, who was featured in the *Register* in 1984 as the "Neighbor of the Week." What brought Lenihan to the attention of the *Register* was his selection as Irishman of the Year by the Friendly Sons of St. Patrick of Central Iowa. Lenihan was being honored for his work in organizing the St. Patrick's Day parade in Des Moines and then following up with additional events that included a dance and a fun run. Lenihan saw these activities as a way to embrace his heritage and encourage other Irish Iowans to join the Friendly Sons. "The only qualification is that you have to be able to trace your ancestry back to Ireland," he said.[147]

Almost as if to give some form and structure to these annual events, young Irish Iowans formed organizations that sponsored floats and dances and other social activities. That certainly was the purpose of the County Johnson Irish, which was established in 1980 in Johnson County, Iowa. The group began with a dozen people in 1980 and had more than three hundred members little more than twenty years later.[148]

But being Irish in Iowa was not all fun and parades in the latter half of the twentieth century. As Iowa celebrated the sesquicentennial of its statehood in 1996, one commentator used the *Register* to remind Iowa that the following year marked the 150th anniversary of the worst year of the Great Hunger in Ireland. The starvation and destitution were the cause for the great diaspora of Irish people to America, including a sizable number to Iowa.

Ed Fallon (*left*) visits with his cousin Jimmy Harrington in County Roscommon in 2016. Proud of his Irish heritage, Fallon has been an advocate for social justice for more than thirty years. *Courtesy of Ed Fallon.*

In a prescient editorial column, Ed Fallon told the story of his family farm in Ireland and his personal and family struggles to maintain the property. This small farm was precious, but the work was too arduous for the Fallon family to sustain. The experience reminded Fallon of the burden faced by his ancestors in the 1840s when they struggled to live on land that was not their own.[149]

So what could Iowans learn from the Irish famine so long ago? "It may be posturing too much," Fallon wrote, "to suggest that, 150 years later, the Irish potato famine has left a positive legacy." And yet there was no question that the famine had changed Ireland and shaped the future of Iowa. "It is not too late to hope that enough of us will commit our lives to resist the heinous forces that threaten our lives, our communities, and our environment," Fallon wrote in conclusion. We all could learn from the experience of the Irish of Iowa and make a better future for our children.

CONCLUSION

F orever Irish. Fast-forward through the first two decades of the twenty-
first century and there is abundant evidence of an intense expansion of
the appreciation for and celebration of Irish culture in Iowa. Looking back
over more than 150 years, the Iowa Irish emphasized that Irish culture in
Iowa was much more than an annual parade in honor of St. Patrick.

That point was emphasized implicitly as Iowa colleges and universities
recognized the continuing importance of Irish culture in the state. During the
early years of the century, both Loras College in Dubuque and St. Ambrose
University in Davenport established academic programs to provide students
with opportunities to study Irish history, literature and culture. In fact, St.
Ambrose also developed courses in Irish dance and music to add additional
dimensions to the program.

SAU expanded its course of study with a program for students to study in
Carlow, Ireland, and through an annual lecture that brings prominent Irish
Americans to campus. In 2008, the university hosted the national meeting of
the American Conference of Irish Studies, a recognition of the institution's
ongoing contributions to the academic study of Irish culture. St. Ambrose
further advanced its commitment to Irish studies by greatly expanding its
book and manuscript holding on Irish subjects. In fact, there is a credible
claim to be made that SAU now has the largest collection of Irish studies
materials of any university in the Midwest.[150]

It also must be said that an appreciation of Irish culture in Iowa was
broader and deeper than these two colleges. Everyday Iowans remained

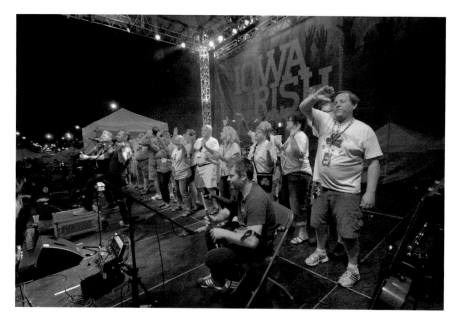

Music is a central part of the annual Irish Fest in Waterloo. Here, festival leaders salute the artistry of the band Gaelic Storm in 2014. *Courtesy of Salina Galvin.*

proud of their heritage and sought ways to express their pride beyond St. Patrick's Day.

That certainly was the motivation behind the reestablishment of the Ancient Order of Hibernians in Dubuque in 2005. The AOH first came to the Key City in 1891 but was disbanded by the middle years of the twentieth century. A renewed interest in the AOH emerged in the first years of the twenty-first century as the Irish of Dubuque made a concerted effort to hold a festival of Irish music and culture each October. That first initial effort led to what is today the annual Irish Hooley, held on the fourth Saturday each August on the grounds of the historic Dubuque Star Brewery. In cooperation with the AOH, the hooley organizers provide a great day of entertainment and education and raise tens of thousands of dollars for worthy causes.

And the Dubuque Irish were not alone in mounting a festival of all things Irish. Since 2007, the Cedar Valley Irish Cultural Association has sponsored Irish Fest, a two-day event, also held each August, that draws tens of thousands of people to downtown Waterloo.[151]

Irish Fest is no small enterprise. Over 1,200 volunteers work for months to prepare for the celebration. And it is no surprise that the Iowa Irish Fest

is among the top five Irish festivals in the nation. "It's definitely become a Midwest fest," noted festival director Chad Shipman. "It's outgrown the Cedar Valley....And our followers from Facebook are from all over the world."[152]

The spirit of the festival is best captured in the words of association president Jim Walsh. "The Irish in Iowa have done such a fine job of melding into their communities," Walsh observed, "that we felt it was time to draw them back out a bit and show them off to their neighbors and as many visitors as we could."[153]

In addition to these annual celebrations in Dubuque and Waterloo is a new, more somber memorial to the Irish at the corner of Second and Harrison Streets in downtown Davenport. There, on a late Sunday afternoon in October 2011, the St. Patrick Society of the Quad Cities dedicated a bronze statue to the sacrifices made by the Irish of Iowa. The statue depicts an Irish family in tattered clothes after the long journey from famine-ravaged Ireland, reaching for the better future that will be theirs in their new home. Speakers at the dedication recalled how much the Irish of Iowa embraced the American dream.[154]

In 2017, the editors of the *Dubuque Telegraph-Herald* captured this spirit in a lavish supplement published on March 16. "It isn't quite St. Patrick's Day," noted editor Amy Gilligan, "but if your roots go back to the Emerald Isle, you probably won't mind getting your Irish on one day early." Under the banner "Tri-States Irish Heritage," the editors compiled stories and photographs that reminded their readers of how it all began.[155]

The fifty-six-page booklet told the story of how Irish immigrants and their children changed the northeast corner of the state. "I love hearing the stories of the generations of Irish relatives and the traditions of their past that remained with them here in Dubuque," wrote Gilligan. "We tried to capture some of that history and lore in this magazine."

The magazine included articles on leadership, heritage, food, dance, music, notable personages and even a chapter on the role of the Irish saloon. It concluded with an article on the local chapter of the Ancient Order of Hibernians and how members of the AOH are preserving Iowa's Irish heritage. "It's nice to see the next generation coming in," noted the local president, "with sons following their fathers as members."

The multitude of programs, memorials, publications and festivals are additions to the ongoing tradition of celebrating St. Patrick's Day across Iowa each March. Dating back at least to the 1860s, the Irish of Iowa have organized to salute their heritage and express their pride. And the tradition has only intensified in the second decade of the twenty-first century.

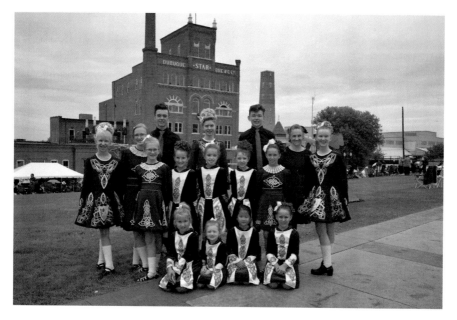

The dancers from the McNulty School of Irish Dance are regular performers at the Irish Hooley held each year in Dubuque. *Courtesy of Robert Felderman/General Bob Photography.*

Each year across the Hawkeye State, the Irish march proudly in Dubuque, the Quad Cities, Cedar Rapids, Des Moines, Emmetsburg and Sioux City, among other communities. Even the small community of Melrose has instituted an annual St. Patrick's Day Homecoming Celebration.

The march is an act of pride and remembrance, of course, but more important, it also is an act of reflection on what it means to be part of a great state in a great nation. "You don't have a St. Patrick's Day for any other ethnic group," noted one proud Irish Iowan. "On St. Patrick's Day we divide the world between the Irish and the people who want to be Irish."[156] Left unsaid is the simple fact that on March 17 each year, every American is magically a little bit Irish!

For more than 150 years, the Irish of Iowa have sustained the roots of their homeland. Even though the family ties to the old country are tenuous at best for the majority, the Irish of Iowa have sustained their emotional attachments to the Emerald Isle and its culture in their hearts and are passing it on to coming generations. Every day in Iowa is, in a small way, St. Patrick's Day. "Forever Irish"—that might well be the motto of the Irish in the Hawkeye State.

NOTES

Chapter 1

1. Calkin, "Irish in Iowa," 84.
2. Carey, "Irish Element in Iowa," 6–8.
3. Deckert and Cherba, "Hanging of Patrick O'Connor," 40–43; Price, "Trial and Execution of Patrick O'Connor," 86–97.
4. Carey, "Irish Element in Iowa," 8–11.
5. *The Hawkeye* (Burlington, IA), April 4, 1844.
6. Quoted in Calkin, "Irish in Iowa," 43.
7. Quoted in Calkin, "Irish in Iowa," 44.
8. Quoted in Calkin, "Irish in Iowa," 46.
9. James McKee of Washington County, Iowa, to John Donnan of Delaware County, Pennsylvania, July 28, 1848, State Historical Society of Iowa, Iowa City, Iowa.
10. Calkin, "Irish in Iowa," 56–58.
11. Ibid., 56.

Chapter 2

12. Copy from the British Library in the author's collection. See also Wyman, *Immigrants in the Valley*, 41.
13. Among the newspapers that published letters from Bishop Loras are the following: *Catholic Advocate* (June 29, August 24, 1839), *Catholic Observer* (July

30, 1850), *Freeman's Journal* (June 20, July 10, August 21, 1854), *Boston Pilot* (October 7, December 26, 1854) and *Boston Pilot* (February 6, February 7 and April 4, 1855). I am grateful to Robert Klein, editor of the Loras Papers, for this information.

14. Quoted in Calkin, "Irish in Iowa," 36–37.

15. The story of Mount Melleray Abbey in Ireland and New Melleray Abbey in Iowa is well told in two books by Tom Walsh: *From the Stones of These Fields* (2000) and *This One Dear Place* (1999), both published by the New Melleray Abbey Trust.

16. The story of Father Hore is told in Rees, *Farewell to Famine*. See also Fitzgerald, "Iowa: Pioneers and Sodbusters," in her book *Uncounted Irish of Canada and the United States*, 193–96, and Schmitz, "Thomas Hore and Wexford Iowa," 3–20.

17. Carey, "Irish Element in Iowa," 37–38; Calkin, "Irish in Iowa," 56–58.

18. For a discussion of typical Irish communities in Iowa before 1860, see Calkin, "Irish in Iowa," 56–64.

19. Anne Brown to her brother, February 13, 1855, typescript available in the Center for Dubuque History, Loras College, Dubuque, Iowa.

20. "Ireland Coming to America," *Burlington Weekly Hawkeye*, November 28, 1863.

21. Alex Aitkin to [a friend in Ireland] from Iowa City, January 14, 1866, copy in the State Historical Society of Iowa, Iowa City, Iowa.

Chapter 3

22. Carey, "Irish Element in Iowa," 4–5. See also Klein, *Foundations*, and Auge, "Dream of Bishop Loras," 170–79.

23. The saga of Father Fitzmaurice's work in Iowa is well documented in Carey, "Irish Element in Iowa," 5–8

24. Carey, "Irish Element in Iowa," 10.

25. On Loras, see Auge, "Dream of Bishop Loras," passim, and William E. Wilke, "Loras, John Mathias Pierre," *Biographical Dictionary of Iowa*, edited by David Hudson, et al. (Iowa City, IA, 2008), 320–21.

26. The legacy of Mary Frances Clarke and the Sisters of Charity of the Blessed Virgin Mary is well told in substantial works by Coogan, *Mary Frances Clarke* and *Price of Our Heritage*, and Lawlor, *Your Affectionate*.

27. Auge, "Dream of Bishop Loras," 174–75.

28. On Smyth, see Schmidt, *Seasons of Growth*, 88–96, and Coogan, "Clement Smyth," 17–37.
29. On Hennessy, see Schmidt, *Seasons of Growth*, 96–105; William E. Wilkie, "Hennessy, John," in *Biographical Dictionary of Iowa*, 229–30; and Coogan, "Redoubtable John Hennessy," 21–34.
30. For the story of Iowa City Catholicism, see Pfeifer, "Making of a Midwestern Catholicism," 290–315.
31. Schmidt, *Seasons of Growth*, 107–15.
32. Dolan, "Irish Parish," 24.
33. Handlin, *Uprooted*, 117.

Chapter 4

34. Calkin, "Irish in Iowa," 63–64.
35. Diner, *Erin's Daughters in America*, 74. Diner's work is exceptional and the best source of information generally on Irish women and how they coped with a new country and culture.
36. Ibid., 42.
37. Ibid., 69.
38. Calkin, "Irish in Iowa," 60–62.
39. Carey, "Irish Element in Iowa," 87–89; McCarty, *Stories of Pioneer Life on the Iowa Prairie*, 6–10, 15–18, 87, 91–95, 144–48.
40. Quoted in Riley, *Frontierswomen*, 105.
41. Diner, *Erin's Daughters in America*, 136.
42. There is an excellent library of works available on Mother Mary Frances Clarke and the Sisters of Charity of the Blessed Virgin Mary. See the following books: Coogan, *Price of Our Heritage*; Lawlor, *Terence James Donaghoe*; and Harrington, *Creating Community*, all published in Dubuque by the Sisters of Charity, BVM.
43. Coogan, *Price of Our Heritage*, I: 272.
44. Ibid., I: 203.
45. DeCock, "Turning Points in the Spirituality of an American Congregation," 65.
46. Schmidt, *Seasons of Growth*, 139.
47. Ibid., 139–40.
48. The Iowa City story can be found in Condon, *From Obscurity to Distinction*.
49. Diner, *Erin's Daughters in America*, xiv.

Chapter 5

50. Among the many useful books on the history of Dubuque, see the following: Lynn, *Dubuque*, updated as www.encyclopediadubuque.org; Childs, *Dubuque*; and Johnson, *Warriors into Workers*.

51. Calkin, "Irish in Iowa," 43; Carey, "Irish Element in Iowa," 17, 32–33, 35–36.

52. The best, if brief, overview of Mahony's life is Vernon L. Volpe, "Mahony, Dennis A.," in *Biographical Dictionary of Iowa*, 335–36. Additional sources are listed in that entry. See also Carey, "Irish Element in Iowa," 40–42.

53. See Wubben, *Civil War Iowa*, 1–17, 39–43, 61–63, 107–11, 198; Klement, "Catholics as Copperheads," 36–57; Cherba, et al., "Mahony."

54. Wilkie, "Hennessy, John," *Biographical Dictionary of Iowa*, 229–30.

55. Carey, "Irish Element in Iowa," 51–52.

56. *Davenport Daily Gazette* as cited in Calkin, "Irish in Iowa," 66.

57. Carey, "Irish Element in Iowa," 52–53.

58. See the following obituaries: "Michael V. Gannon," *Annals of Iowa* 15 (1926): 473; and "Michael V. Gannon, Well Known Lawyer and Orator, Dies Here Sunday Afternoon," *Davenport Democrat and Leader*, March 8, 1926.

59. See Sharon's lengthy obituary in the *Iowa Catholic Messenger*: "Our Dead: Founder of the Messenger," June 2, 1888. Also valuable is "History of the Catholic Messenger" [unpublished manuscript, 1948], held by the office of the *Catholic Messenger* in Davenport.

60. Calkin, "Irish in Iowa," 93–94.

61. Ibid., 96.

62. Avella, "Clergy as Community Builders: Father John Brazill—Shaper of Early Des Moines," in *Catholic Church in Southwest Iowa*, 16–19. See also Carey, "Irish Element in Iowa," 81.

63. Avella, *Catholic Church in Southwest Iowa*, 23–26.

64. On the Irish in Sioux City, see Roder, *Frontiers of Faith*, and Sioux City Public Museum, "Irish in Sioux City," PowerPoint presentation produced by the Sioux City Public Museum.

65. Carey, "Irish Element in Iowa," 91.

66. Roder, "Father Bartholomew Lenehan and St. Mary's Parish of Sioux City," in *Frontiers of Faith*, 119–20.

67. See his obituary: "John Brennan," *Annals of Iowa* 4 (1901): 638; see also Calkin, "Irish in Iowa," 94–95.

Chapter 6

68. For a brief discussion of the effort to lure Irish immigrants to Iowa, see Herr, *Critical Regionalism and Cultural Studies*, 86–89, and Calkin, "Irish in Iowa," 43–47.
69. Quoted in Calkin, "Irish in Iowa," 44–45.
70. Quoted in Calkin, "Irish in Iowa," 46–47.
71. Quoted in Calkin, "Irish in Iowa," 47.
72. For an excellent discussion of these booklets, see Herr, *Critical Regionalism and Cultural Studies*, 86–87.
73. Calkin, "Irish in Iowa," 56–64.
74. Ibid., 58–59.
75. Information on the Kelly family was provided by Kenneth Donnelly of West Liberty, Iowa, a great-great-grandchild of Patrick and Mary Kelly. The information comes from a family genealogy prepared by Vivian Kelly, grandchild of the Kellys.
76. McCarty, *Stories of Pioneer Life*, 91–93.
77. The story of Martin Flynn and his family can be found in Murray, "Martin Flynn Farm," 481–93.
78. On the effort to encourage the Irish to settle on farms in the Middle West, see French, "'We're All Irish,'" 9–24; Henthorne, *Irish Catholic Colonization Association*; O'Grady, "Irish Colonization in the United States," 387–407.
79. "A Truly Rooseveltian Family," *Iowa State Register*, July 16, 1905.

Chapter 7

80. Quoted in Calkin, "Irish in Iowa," 63. The best study of the working class in Dubuque has been done by Scharnau, "From Pioneer Days to the Dawn of Industrial Relations," 201–24; "Workers and Politics," *Annals of Iowa* 48 (1987): 353–77; and "The Knights of Labor in Iowa," *Annals of Iowa* 50 (1991): 861–91.
81. For Sioux City, see the work of Silag, particularly "Opportunity and Achievement in Northwest Iowa," 623–49.
82. Ibid., 627.
83. On the Irish and their work on the railroads, see the following: Wyman, *Immigrants in the Valley*, 101–5; Clark, "Steel Rail Men," in *Hibernia America*, 23–33.

84. On the story of the Shelley family, see Swisher, "Kate Shelley," 45–55, and Hubbard, "Legend of Kate Shelley," in *Railroad Avenue*, 134–46. The most complete assessment of Shelley is in Grant, "Kate Shelley," 138–44.
85. Quoted in Hubbard, "Legend of Kate Shelley," 143–46.
86. Parker, "Irish and Scotch-Irish," in *Iowa*, 140.

Chapter 8

87. The best work on the Fenians in Iowa can be found in Myers, "Fenians in Iowa," 54–64. See also Calkin, "Irish in Iowa," 71–74.
88. "The Fenian War Is Ended," *Cedar Falls Gazette*, June 15, 1866.
89. *Davenport Daily Gazette*, June 11, 1872.
90. *The O'Connell Centennial Celebration, Dubuque, Iowa, August 6, 1875* [pamphlet] (Dubuque, 1877).
91. Quoted in Calkin, "Irish in Iowa," 77.
92. The Parnell visit is well documented in Colton, "Parnell's Mission to Iowa," 312–27. See also Green, "American Catholics and the Irish Land League," 19–42; Calkin, "Irish in Iowa," 77; Myers, "Fenians in Iowa," 56–59.
93. *Iowa State Register*, November 22, 1879.
94. *Iowa State Register*, November 2, 1879.
95. *Iowa State Register*, February 11, 1880. See also Colton, "Parnell's Visit to Iowa," 325.
96. See Myers, "Fenians in Iowa," 59–63.
97. The quote is from Myers, "Fenians in Iowa," 59. The story of fear and apprehension about Brennan and Gannon is also well told in Myers, 59–63.
98. Ibid., 60.
99. *Iowa State Register*, February 24, 1886. See also Myers, "Fenians in Iowa," 59–63.

Chapter 9

100. Tocqueville is widely quoted on this topic. See Tocqueville, *Democracy in America*, 1: 300–2.
101. See Mathias, "Know Nothings in Iowa," 25–42. The quote is on p. 29. See also Dykstra, "Know Nothings Nobody Knows," 5–24.

102. *Davenport Gazette*, June 15, 1854. See also Mathias, "Know Nothings in Iowa," 33–34.

103. Schmidt, *Seasons of Growth*, 84–87.

104. Dykstra, *Bright Radical Star*, 129–36.

105. Mathias, "Know Nothings in Iowa," 35.

106. Schmidt, *Seasons of Growth*, 88.

107. Mathias, "Know Nothings in Iowa," 30.

108. Manfra, "Hometown Politics and the American Protective Association," 136–96.

109. *Iowa Catholic Messenger*, June 18 and June 25, 1892. See also Schmidt, *Seasons of Growth*, 124–25.

110. *Iowa State Register*, December 24, 1892. See also Schmidt, *Seasons of Growth*, 125.

Chapter 10

111. Ward documented his own life in Melrose in a series of essays published late in life in the pages of the journal *Modern Age*. The following were used in this chapter: "Looking Down Our Noses," 48–57; "Going on West," 78–83; "Those Puritanic American Irish!" 94–98; "Going to a Rural School," 191–93; "Teaching at Tyrone," 372–76. For more on Ward, also see Dye, "Leo R. Ward," 1–17.

112. Ward, *Holding Up the Hills*.

113. Ward, "Going on West," 83.

114. Ibid., 79.

115. Ibid., 82.

116. Ward, "Going to a Rural School," 191.

117. Ward, "Teaching at Tyrone," 372.

118. Dye, "Leo R. Ward," 3–4.

119. Ward, "Man in the Cutaway Suit," 166. See also Dye, "Leo R. Ward," 6.

120. Ward, "Looking Down Our Noses," 50.

121. See the following stories: "Ireland Is Being Depopulated," *Iowa State Register*, March 28, 1904; and "Irish Patriots to Free Ireland," *Iowa State Register*, November 28, 1904.

122. "Irish Patriots to Free Ireland," *Iowa State Register*, November 28, 1904.

123. See the following stories: "Ireland's Sad Plight," *Iowa Catholic Messenger*, April 2, 1904; "To Stem the Tide," *Iowa Catholic Messenger*, April 23, 1904;

"The Sinn Fein Movement," *Iowa Catholic Messenger*, September 12, 1907; "Working Against Ireland," *Iowa Catholic Messenger*, November 26, 1914. See also Rowland, "American Catholic Press," 67–83.

124. Rowland, "American Catholic Press," 72–73.

125. "Declares Ireland Another Belgium," *Iowa State Register*, September 14, 1920.

126. A full account of the incident is in Cahill, "Ku Klux Klan in West Branch," copy provided to the author by J.Q. Cahill.

127. See Duncan, "Tammany Farmer."

Chapter 11

128. Cahill, "Ku Klux Klan in West Branch," 19–20.

129. Ward, *Holding Up the Hills*, 21.

130. Ibid., 26.

131. Ibid., 22–23.

132. Ibid., 82.

133. Ibid., 147.

134. Satterfield, *We Band of Brothers*, 1–15. See also Kuklick, *Fighting Sullivans*, 1–34.

135. Satterfield, *We Band of Brothers*, 22.

136. Kuklick, *Fighting Sullivans*, 36–37.

137. Satterfield, *We Band of Brothers*, 4–7.

138. This comment and others like it can be found in Satterfield, *We Band of Brothers*, 188 and 169–203. See also Kuklick, *Fighting Sullivans*, passim.

Chapter 12

139. For a general history of St. Patrick's Day celebrations in the United States and around the world, see Cronin and Adair, *Wearing of the Green*.

140. "St. Patrick's Day," *Mason City Globe Gazette*, March 17, 1934. See also "Nostalgia for th' Ould Sod," *Des Moines Register*, March 17, 1946.

141. Plambeck, "A Great Day for the Irish."

142. Mills, "What Would Iowa Be without the Irish?"

143. Murray, "Wearing the Red."

144. McCoy, "Irish American Ties to Ireland."

145. Carney, "Over the Fence: We Call Him Blind."

146. Stuart, "Their Music Echoes Irish Lilts, Lore."
147. Pearson, "Spirit of St. Patrick Lasts All Year for This Proud Son of Ireland."
148. See, for example, Gannon, "There's a Bit of Ireland All Over"; Raffensberger, "Irish Eyes Dance a Jig Over Parade"; Del Campo, "Iowa, Michigan Towns Are Working Together to Preserve Statue"; and Ulstad, "Irish March to Mark Day."
149. Fallon, "Remembering Ireland."

Conclusion

150. See the St. Ambrose University website, www.sau.edu/library.
151. Cedar Valley Irish Cultural Association website, www.iowairishfest. com.
152. Kinney, "Update: Iowa Irish Fest."
153. "Our Mission," www.iowairishfest.com.
154. Trainor, "New Sculpture Looks at 'Plight of the Irish'"; Gaul, "Irish Statues Tell a Compelling Story."
155. Gilligan, *Tri-States Irish Heritage*.
156. Hupp, "Professor Studies the Irish in Iowa."

BIBLIOGRAPHY

Unpublished Sources

Carey, Mary Helen. "The Irish Element in Iowa to 1865." Master's thesis, Catholic University of America, 1944.

Duncan, Jason. "Tammany Farmer: Al Smith and the 1928 Presidential Campaign in Iowa." Unpublished research paper, n.d. Copy held by the State Historical Society of Iowa, Iowa City.

Johnson, Kay. "The Ku Klux Klan in Iowa: A Study in Intolerance." Master's thesis, University of Iowa, 1967.

Sioux City Public Museum. "The Irish in Sioux City." PowerPoint presentation, n.d., Sioux City Public Museum.

Stewart, Jennie. "Reconstruction of the History of Some Emigrants from County Down, Ireland." Unpublished research paper, 1981. Copy in the possession of the Center for Dubuque History, Loras College.

Books

Avella, Steven M. *The Catholic Church in Southwest Iowa: A History of the Diocese of Des Moines*. Collegeville, MN, 2018.

Bogue, Allan G. *From Prairie to Corn Belt: Farming on the Illinois and Iowa Prairies in the Nineteenth Century*. Chicago, 1963.

Childs, Chandler C. *Dubuque: Frontier River City*. Dubuque, IA, 1984.

Clark, Dennis. *Erin's Heirs: Irish Bonds of Community*. Lexington, KY, 1991.
————. *Hibernia America: The Irish and Regional Cultures*. Westport, CT, 1986.

Condon, Mary Brigid. *From Obscurity to Distinction: The Story of Mercy Hospital, Iowa City, 1873–1993*. Iowa City, IA, 1993.

Coogan, Mary Jane. *Mary Frances Clarke, Foundress*. Dubuque, IA, 1977.
————. *The Price of Our Heritage: Sisters of Charity of the Blessed Virgin Mary*. 2 vols. Dubuque, IA, 1978.

Cronin, Mike, and Daryl Adair. *The Wearing of the Green: A History of St. Patrick's Day*. London, 2002.

Diner, Hasia R. *Erin's Daughters in America: Irish Immigrant Women in the Nineteenth Century*. Baltimore, MD, 1983.

Donnelly, Kenneth. *St. Patrick's Church: Iowa City, Iowa 1872–1972*. Iowa City, IA, 1972.

Dykstra, Robert R. *Bright Radical Star: Black Freedom and White Supremacy on the Hawkeye Frontier*. Cambridge, MA, 1993.

Emmons, David M. *Beyond the American Pale: The Irish in the West, 1845–1910*. Norman, OK, 2010.

Fanning, Charles. *The Irish Voice in America: 250 Years of Irish-American Fiction*. 2nd ed. Lexington, KY, 2000.

Fitzgerald, Margaret. *The Uncounted Irish in Canada and the United States*. Toronto, ON, 1990.

Gilligan, Amy, ed. *Tri-States Irish Heritage: A Supplement to the Dubuque Telegraph-Herald*. March 16, 2017.

Handlin, Oscar. *The Uprooted*. Boston, 1951.

Harrington, Ann M. *Creating Community: Mary Frances Clarke and Her Companions*. Dubuque, IA, 2004.

Henthorne, Mary Evangela. *The Irish Catholic Colonization Association of the United States*. Urbana, IL, 1932.

Herr, Cheryl. *Critical Regionalism and Cultural Studies: From Ireland to the American Midwest*. Gainesville, FL, 1996.

Hoffman, M.M. *Arms and the Monk! The Trappist Saga in Mid-America*. Dubuque, IA, 1952.

Hubbard, Freeman H. "Legend of Kate Shelley." In *Railroad Avenue: Great Stories and Legends of American Railroading*. New York, 1945.

Hudson, David, Loran Horton and Marvin Bergman, eds. *Biographical Dictionary of Iowa*. Iowa City, IA, 2008.

Johnson, Russell L. *Warriors into Workers: The Civil War and the Formation of Urban Industrial Society in a Northern City*. New York, 2003.

Kinzer, Donald L. *An Episode in Anti-Catholicism: The American Protective Association.* Seattle, WA, 1964.

Klein, Robert F., ed. *Dubuque: Frontier River City.* Dubuque, IA, 1984.

————, ed. *Foundations: The Letters of Mathias Loras, D.D., Bishop of Dubuque.* Dubuque, IA, 2004.

Kuklick, Bruce R. *The Fighting Sullivans: How Hollywood and the Military Makes Heroes.* Lawrence, KS, 2016.

Lawlor, Kathryn, ed. *Terrence James Donaghoe: Co-founder of the Sisters of Charity, BVM.* Dubuque, IA, 1995.

————. *Your Affectionate: Commentary on Mary Frances Clarke's Writings.* Dubuque, IA, 2003.

Lynn, Randolph. *Dubuque: The Encyclopedia.* Dubuque, IA, 1991. Updated as www.encyclopediadubuque.org.

Mahoney, Timothy R. *From Hometown to Battlefield in the Civil War Era: Middle Class Life in Midwest America.* New York, 2016.

McCarty, Dwight G. *Stories of Pioneer Life on the Iowa Prairie.* Emmetsburg, IA, 1973.

Parker, George. "The Irish and Scotch-Irish." In *Iowa: Pioneer Foundations.* Iowa City, IA, 1940.

Rees, Jim. *A Farewell to Famine.* Arklow, Ireland, 1994.

Riley, Glenda. *Frontierswoman: The Iowa Experience.* Ames, IA, 1981.

Roder, Richard J. *Frontiers of Faith: A History of the Diocese of Sioux City.* Sioux City, IA, 2011.

Rosenberg, Morton M. *Iowa on the Eve of the Civil War.* Norman, OK, 1972.

Satterfield, John. *We Band of Brothers: The Sullivans and World War II.* Parkersburg, IA, 1996.

Schmidt, M. Madeleine. *Seasons of Growth: A History of the Diocese of Davenport, 1881–1981.* Davenport, IA, 1981.

Tocqueville, Alexis de. *Democracy in America.* 2 vols. New York, 1945.

Walsh, Tom. *From the Stones of These Fields.* Peosta, IA, 2000.

————. *This One Dear Place.* Peosta, IA, 1999.

Ward, Leo R. *Holding Up the Hills: The Biography of a Neighborhood.* New York, 1941.

Wubben, Hubert H. *Civil War Iowa and the Copperhead Movement.* Ames, IA, 1980.

Wyman, Mark. *Immigrants in the Valley: The Irish, Germans and Americans in the Upper Mississippi Valley, 1830–1860.* Chicago, 1984.

Articles

Auge, Thomas E. "The Dream of Bishop Loras: A Catholic Iowa." *Palimpsest* 61 (1980): 170–79.

Cahill, James Quinten. "The Ku Klux Klan in West Branch, Iowa, 1918–1923." *Cedar County Historical Review* (2005).

Calkin, Homer L. "The Irish in Iowa." *Palimpsest* 45 (1964): 33–96.

Carney, Tom. "Over the Fence: We Call Him Blind." *Des Moines Register*, November 30, 1983.

Cherba, Constance, et al. "Mahony: Political Dissident, Prisoner of State." *Civil War Times* 46 (2007).

Colton, Kenneth. "Parnell's Mission to Iowa." *Annals of Iowa* 22 (1940): 312–27.

Coogan, M. Jane. "Clement Smyth, OSCO: Trappist Monk and Frontier Prelate." *American Catholic Studies* 100 (1989): 17–37.

———. "The Redoubtable John Hennessy, The First Archbishop of Dubuque." *Mid-America* 62 (1980): 21–34.

Cook, Robert. "The Political Culture of Antebellum Iowa: An Overview." *Annals of Iowa* 52 (1993): 225–50.

Deckert, Edward E., and Constance R. Cherba. "The Hanging of Patrick O'Connor and Frontier Justice." *Wild West* 21 (June 2008): 40–43.

DeCock, Mary. "Turning Points in the Spirituality of an American Congregation: The Sisters of Charity of the Blessed Virgin Mary." *U.S. Catholic Historian* 10 (1991/1992): 59–69.

Del Campo, Lil Gomez. "Iowa, Michigan Towns Are Working Together to Preserve Statue." *Des Moines Register*, July 7, 1991.

Dolan, Jay P. "The Irish Parish." *U.S. Catholic Historian* 25 (2007): 13–24

Dunn, Edmond J. "Iowa." In *The Encyclopedia of the Irish in America*, edited by Michael J. Glazier, 411–16. Notre Dame, IN, 1999.

Dye, Ryan D. "Leo R. Ward: Irish America's Rural Man of Letters." *American Catholic Studies* 118 (2007): 1–17.

Dykstra, Robert R. "The Know Nothings Nobody Knows: Political Nativists in Antebellum Iowa." *Annals of Iowa* 53 (1994): 5–24.

Fallon, Ed. "Remembering Ireland." *Des Moines Register*, March 16, 1997.

French, Brigittine M. "'We're All Irish': Transforming Irish Identity in a Midwestern Community." *New Hibernia Review* 11 (2007): 9–24.

Gannon, James P. "There's a Bit of Ireland All Over." *Des Moines Register*, March 13, 1988.

Gaul, Alma. "Irish Statues Tell a Compelling Story." *Quad City Times*, November 2011.

Grant, H. Roger. "Kate Shelley and the Chicago & Northwestern Railway." *Palimpsest* 76 (1995): 138–44.

Green, James J. "American Catholics and the Irish Land League, 1879–1882." *Catholic Historical Review* 35 (1949): 19–42.

Hupp, Staci. "Professor Studies the Irish in Iowa." *Des Moines Register*, March 17, 2000.

Kinney, Pat. "Update: Iowa Irish Fest in Waterloo Next Weekend." *Waterloo-Cedar Falls Courier*, July 31, 2017.

Klement, Frank L. "Catholics as Copperheads during the Civil War." *Catholic Historical Review* 80 (1994): 36–57.

Lendt, David L. "Iowa and the Copperhead Movement." *Annals of Iowa* 40 (1970): 412–27.

Manfra, Jo Ann. "Hometown Politics and the American Protective Association, 1887–1890." *Annals of Iowa* 55 (1996): 138–66.

Mathias, Ronald. "The Know Nothings in Iowa: Opportunity and Frustration in Antebellum Politics." *Annals of Iowa* 53 (1994): 25–42.

McCoy, Maureen. "Irish American Ties to Ireland." *Des Moines Register*, May 24, 1981.

Mills, George. "What Would Iowa Be Without the Irish?" *Des Moines Register*, March 17, 1968.

Murray, W. Cotter. "Wearing the Red." *Des Moines Register*, August 8, 1976.

Murray, William G. "The Martin Flynn Farm: From Public Land in 1845 to Living History Farms in 1970." *Annals of Iowa* 40 (1972): 481–93.

Myers, Phillip E. "The Fenians in Iowa." *Palimpsest* 62 (1981): 54–64.

O'Grady, John. "Irish Colonization in the United States." *Studies: An Irish Quarterly Review* 19 (1930): 387–407.

Pearson, Deidre. "Spirit of St. Patrick Lasts All Year for This Proud Son of Ireland." *Des Moines Register*, April 4, 1984.

Pfeifer, Michael J. "The Making of a Midwestern Catholicism: Identities, Ethnicity, and Catholic Culture in Iowa City, 1840–1940." *Annals of Iowa* 76 (2017): 290–315.

Plambeck, Herb. "A Great Day for the Irish—In Every County of State of Iowa." *Carroll Daily Times Herald*, March 17, 1964.

Price, Eliphat. "The Trial and Execution of Patrick O'Connor at the Dubuque Mines in the Summer of 1834." *Palimpsest* 1 (1920): 86–97.

Raffensberger, Gene. "Irish Eyes Dance a Jig Over Parade." *Des Moines Register*, March 15, 1988.

Rowland, Thomas J. "The American Catholic Press and the Easter Rebellion." *Catholic Historical Review* 81 (1995): 67–83.

Ryan, Thomas G. "Ethnicity in the 1940 Presidential Election in Iowa: A Quantitative Approach." *Annals of Iowa* (1977): 615–35.

Scharnau, Ralph. "From Pioneer Days to the Dawn of Industrial Relations: The Emergence of the Working Class in Dubuque, 1833–1855." *Annals of Iowa* 70 (2011) 201–24.

———. "The Knights of Labor in Iowa." *Annals of Iowa* 50 (1990): 861–91.

———. "Workers and Politics." *Annals of Iowa* 48 (1987): 353–77.

Schmitz, Kenneth P. "Thomas Hore and Wexford Iowa." *The Past* 11 (1975/1976): 3–20.

Silag, William. "Opportunity and Achievement in Northwest Iowa, 1860–1900." *Annals of Iowa* 50 (1990): 623–49.

Stuart, Scott. "Their Music Echoes Irish Lilts, Lore." *Des Moines Register*, March 14, 1984.

Swisher, J.A. "Kate Shelley." *Palimpsest* 6 (1925): 45–55.

Trainor, Steve. "New Sculpture Looks at 'Plight of the Irish.'" *Quad City Times*, October 30, 2011.

Ulstad, Larissa. "Irish March to Mark Day." *Iowa City Press Citizen*, March 17, 1998.

Ward, Leo R. "Going on West." *Modern Age* 14 (1969–70): 78–83.

———. "Going to a Rural School, 1900–1906." *Modern Age* 22 (1978): 191–93.

———. "Looking Down Our Noses." *Modern Age* 12 (1967–68): 48–57.

———. "The Man in the Cutaway Suit." *Commonweal*, April 25, 1969, 166.

———. "Teaching at Tyrone, 1900–1914." *Modern Age* 26 (1982): 372–76.

———. "Those Puritanic American Irish!" *Modern Age* 20 (1976): 94–98.

Wubben, Hubert. "Dennis Mahony and the *Dubuque Herald*, 1860–1863." *Iowa Journal of History* 56 (1958): 289–320.

Websites

Friendly Sons of St. Patrick of Central Iowa. www.friendlysonsiowa.com. Information on the Friendly Sons of St. Patrick of Central Iowa and the organization's varied activities.

Iowa Irish Fest. www.iowairishfest.com. Information on the Cedar Valley Irish Cultural Association and its annual festival of Irish music, dance and sport held each year in downtown Waterloo, Iowa.

Irish Hooley. www.irishhooley.org. Information on the Irish Hooley of Dubuque and its annual celebration of Irish music and culture.

Newspapers.com. www.newspapers.com. Access to back issues of numerous
 Iowa newspapers.
St. Ambrose University. www.sau.edu/library. Information on the Irish book
 collections available in the library of St. Ambrose University.
St. Patrick's Association of Emmetsburg. www.emmetsburgirishgifts.com.
 Information on the St. Patrick's Association of Emmetsburg, Iowa, and
 the community's annual St. Patrick's Day festivities.
St. Patrick Society. www.stpatsqc.com. Information on the St. Patrick's
 Society of the Quad Cities and the organization's plans and activities,
 including its annual St. Patrick's Day parade.

INDEX

ABOUT THE AUTHOR

Timothy Walch is the director emeritus of the Herbert Hoover Presidential Library and a longtime member of the Iowa Historical Records Advisory Board. Dr. Walch is the author or editor of more than twenty books and hundreds of essays and reviews on a wide range of historical topics. His interest in the Irish is manifest in the Timothy Walch Collection of Irish and Catholic Americana at the St. Ambrose University Library in Davenport, Iowa.

Visit us at
www.historypress.com